LUKAS & STERNBERG, NEW YORK 013

DANIEL BIRNBAUM IS RECTOR OF THE STÄDELSCHULE IN FRANKFURT AM MAIN AND DIRECTOR OF ITS PORTIKUS GALLERY. SINCE 2003 HE IS A MEMBER OF THE BOARD OF FRANKFURT'S INSTITUT FÜR SOZIAL-FORSCHUNG. A CONTRIBUTING EDITOR OF *ARTFORUM*, HE IS THE AUTHOR OF A NUMBER OF BOOKS ON ART AND PHILOSOPHY, INCLUDING *THE HOSPITALITY OF PRESENCE: PROBLEMS OF OTHERNESS IN HUSSERL'S PHENOMENOLOGY* (1998) AND, TOGETHER WITH CARSTEN HÖLLER, *PRODUCTION* (2000). HE CO-CURATED THE 50TH VENICE BIENNALE (2003) AND THE FIRST INSTALLMENT OF THE MOSCOW BIENNALE (2005).

DANIEL BIRNBAUM
CHRONOLOGY

LUKAS & STERNBERG, NEW YORK

Daniel Birnbaum

Chronology

Publisher: Lukas & Sternberg, New York

© 2005 Daniel Birnbaum, Lukas & Sternberg

Artistic intervention in the cover design by Franz von Stauffenberg, Berlin

Series Editor: Caroline Schneider

Text Editor: April Elizabeth Lamm

Design: Katrin Tüffers, Markus Weisbeck, surface, Berlin/Frankfurt am Main

Printing and binding: Medialis, Berlin

ISBN 0-9745688-3-X

Lukas & Sternberg

Caroline Schneider

1182 Broadway #1602, New York NY 10001

Linienstraße 159, D-10115 Berlin

mail@lukas-sternberg.com, www.lukas-sternberg.com

CONTENTS

TIME, SAID AUSTERLITZ IN THE OBSERVATION ROOM IN GREENWICH, WAS BY FAR THE MOST ARTIFI-
CIAL OF ALL OUR INVENTIONS, AND IN BEING BOUND TO THE PLANET TURNING ON ITS OWN AXIS WAS
NO LESS ARBITRARY THAN WOULD BE, SAY, A CALCULATION BASED ON THE GROWTH OF TREES OR
THE DURATION REQUIRED FOR A PIECE OF LIMESTONE TO DISINTEGRATE, QUITE APART FROM THE
FACT THAT THE SOLAR DAY WHICH WE TAKE AS OUR GUIDELINE DOES NOT PROVIDE ANY PRECISE
MEASUREMENT, SO THAT IN ORDER TO RECKON TIME WE HAVE TO DEVISE AN IMAGINARY, AVERAGE
SUN WHICH HAS AN INVARIABLE SPEED OF MOVEMENT AND DOES NOT INCLINE TOWARDS THE EQUA-
TOR IN ITS ORBIT. IF NEWTON THOUGHT, SAID AUSTERLITZ, POINTING THROUGH THE WINDOW AND
DOWN THE CURVE OF THE WATER AROUND THE ISLE OF DOGS GLISTENING IN THE LAST OF THE DAY-
LIGHT, IF NEWTON REALLY THOUGHT THAT TIME WAS A RIVER LIKE THE THAMES, THEN WHERE IS
ITS SOURCE AND INTO WHAT SEA DOES IT FINALLY FLOW? EVERY RIVER, AS WE KNOW, MUST HAVE
BANKS ON BOTH SIDES, SO WHERE, SEEN IN THOSE TERMS, WHERE ARE THE BANKS OF TIME? WHAT
WOULD BE THIS RIVER'S QUALITIES, QUALITIES PERHAPS CORRESPONDING TO THOSE OF WATER,
WHICH IS FLUID, RATHER HEAVY, AND TRANSLUCENT? IN WHAT WAY DO OBJECTS IMMERSED IN TIME
DIFFER FROM THOSE LEFT UNTOUCHED BY IT? WHY DO WE SHOW THE HOURS OF LIGHT AND DARK-
NESS IN THE SAME CYCLE? WHY DOES TIME STAND ETERNALLY STILL AND MOTIONLESS IN ONE
PLACE, AND RUSH HEADLONG BY IN ANOTHER? COULD WE NOT CLAIM, SAID AUSTERLITZ, THAT TIME
ITSELF HAS BEEN NON-CONCURRENT OVER THE CENTURIES AND THE MILLENNIA? IT IS NOT SO
LONG AGO, AFTER ALL, THAT IT BEGAN SPREADING OUT OVER EVERYTHING. AND IS NOT HUMAN LIFE
IN MANY PARTS OF THE EARTH GOVERNED TO THIS DAY LESS BY TIME THAN BY THE WEATHER,
AND THUS BY AN UNQUANTIFIABLE DIMENSION WHICH DISREGARDS LINEAR REGULARITY, DOES NOT
PROGRESS CONSTANTLY FORWARD BUT MOVES IN EDDIES, IS MARKED BY EPISODES OF CONGES-
TION AND IRRUPTION, RECURS IN EVER-CHANGING FORM, AND EVOLVES IN NO ONE KNOWS WHAT
DIRECTION?[01] (W.G. SEBALD)

01 W. G. SEBALD, *AUSTERLITZ*, TRANS. A. BELL (LONDON: PENGUIN, 2001), PP. 141F.

SYNCOPE

THE ETERNAL RETURN IS A NECESSITY THAT MUST BE WILLED: ONLY HE WHO I AM NOW CAN WILL THE NECESSITY OF MY RETURN AND ALL THE EVENTS THAT HAVE LED TO WHAT I AM ...[02]

(PIERRE KLOSSOWSKI)

I tend to return – eternally – to the Eternal Return. This doctrine has been formulated in the following manner: the number of particles that compose the world is immense but finite, and, as such, only capable of a finite (though also immense) number of permutations. In an infinite stretch of time, the number of possible constellations must be run through, and the universe has to repeat itself. Once again, you will be born from a belly; once again your skeleton will grow; once again the identical page will reach your same hands; once again you will follow the course of all the hours of your life until that of your incredible death. Since everything is bound to return, nothing is unique, not even these lines, stolen from a writer (Borges) who in turn has pilfered the ideas from someone else (Nietzsche), who in the autumn of 1883 declared:

THIS SLOW SPIDER DRAGGING ITSELF TOWARDS THE LIGHT OF THE MOON AND THAT SAME MOONLIGHT, AND YOU AND I WHISPERING AT THE GATEWAY, WHISPERING OF ETERNAL THINGS, HAVEN'T WE ALREADY COINCIDED IN THE PAST? AND WON'T WE HAPPEN AGAIN ON THE LONG ROAD, ON THIS LONG TREMULOUS ROAD, WON'T WE RECUR ETERNALLY?[03]

A necessity that must be willed: everything that happens in the universe has happened before and is destined to happen again, preceded and followed every time by exactly the same events. The finitude of the universe and the infinity of time make this seeming paradox possible. The same arrangements, dreary or otherwise, are

02 PIERRE KLOSSOWSKI, *NIETZSCHE AND THE VICIOUS CIRCLE*, TRANS. D. W. SMITH (LONDON: THE ATHLONE PRESS, 1997), P. 57.

03 FROM NIETZSCHE'S *THUS SPOKE ZARATHUSTRA*, QUOTED IN *J. L. BORGES: SELECTED NON-FICTIONS*, ED. ELIOT WEINBERGER (LONDON: PENGUIN, 1999), PP. 117F.

bound to recur. Thus Donny, the good-looking but naive young guy in Stan Douglas's 1998 video installation *Win, Place or Show*, will again and again present his wide-eyed theories about mystical forces that are responsible for human suffering. And Bob, the slightly older and more rough-hewn tenant of the apartment where the action takes place, will forever explain a game involving horse racing in a manner that irks Donny and leads to a fight that Bob seems to win, but which comes to a close with the laconic remark, "If I wasn't so tired, I'd slug you again." And Donny will once again reply, "I know it." And so it goes, eternally.

Douglas has produced this finite cosmos, and exactly the same dialogue and camera shots will, in fact, recur – but only after some 20,000 hours, in accordance with a computer program that randomizes the screening of two wall-size video projections, each of which portrays "the same" action from a different camera angle. After about six minutes, what appears to be a loop starts all over again, but the repetition is not identical. The slight alteration – the combination of skewed shots mutating constantly – gives one the feeling that maybe this time the outcome will be different. It never is: the two guys always end up carrying out their hopeless wrestling match. They're locked inside a machine that offers no escape.

As is always true of Douglas's installations, there's much more here than meets the eye. My first impressions concerned the various incongruities: here are two lower-class men – dock workers, perhaps – quarreling and wrestling in lodgings that appear, well, weirdly chic. The chair Bob sits in while reading the *Daily Racing Form* is a Bruno Mathsson. In fact, the whole set reminded me of the Scandinavian modernism revival aggressively promoted in those very years by *Wallpaper** magazine. The hostile dialogue and the heavy rain over a gloomy high-rise cityscape glimpsed through the large windows create a curious contrast to this slick setting. And why exactly are

these guys living together? Because they can't afford separate apartments? Because they're gay?

Of course, the cool camera work, with extreme angles and close-ups reminiscent of American TV dramas of the '60s, should have made it obvious that the setting belongs not to the cynical era of *Wallpaper** but to an earlier time, when this furniture still spoke of utopian hopes. In fact, the theme of this repetitive yet strangely riveting double projection is neither thoroughbred racing nor conspiracy theories but rather the failed promises of modernism. As in all of Douglas's work, the setting and ideological context have been meticulously researched and rigorously mapped out. Together with the architect Robert Kleyn, the artist constructed the set according to authentic blueprints from a '50s plan for the total redevelopment of Vancouver's Strathcona district, a scheme unrealized but intended as a low-rent high-rise solution to the housing problems facing an enormous population of single, male workers. Donny and Bob occupy one of the dehumanizing units in these complexes, and their circular litany of endless desperation gives expression to a predicament reminiscent of Samuel Beckett's novel *The Unnamable*, living "like a caged beast born of caged beasts born of caged beasts born of caged beasts born in a cage and dead in a cage, born and then dead, born in a cage and then dead in a cage."[04] The fact that, a few decades later, their modernist prison cell, intended for low-cost mass production, segues smoothly into the pages of high-end design magazines makes the irony that much more diabolical. From the city planner's grisly dream of rationalized life to a nightmare fetishized by the well-off, this *is* a dismal piece.

04 SAMUEL BECKETT, *THE UNNAMEABLE*, IN *THREE NOVELS* (NEW YORK: GROVE PRESS, 1965), PP. 386F.

Modernism – its failures as well as the fleeting moments of hope in which a constellation of freedom appears possible – is an overriding theme in much of Douglas's work. At Documenta IX, in 1992, the artist presented *Hors-champs*, which offered a glimpse into an alternative social order and the liberating forms of self-expression that modernism promised. Scenes from a free-jazz session – featuring four American musicians active in Paris since the '60s – are projected in black and white on both sides of a thin screen hanging in the middle of an otherwise empty room. The piece, like so many of Douglas's works, registers on many levels, and I remember enjoying it without worrying much about the exact origin of the music, the social context of the performance, or the camera work involved in capturing the event. That the music of choice, a 1965 Albert Ayler composition, seems to cite two ideologically overdetermined anthems, *La Marseillaise* and *The Star-Spangled Banner*, is no accident: Douglas, after all, stages this performance as part of his research into the emancipatory aspirations of the free-jazz movement, which some took as a marker for an alternative society. Rather than nostalgia, Douglas's double-sided rendition of this moment of hope – ultimately unrealized, like most facets of the '68 revolution – brings out the discrepancy between the way these concerts were presented on TV (where the camera work mainly emphasized solo performances) and the group dynamics of the interchange. The music is what ties everything together, but the thin screen holds two realities apart – that of something like the "official" camera, and that which is perhaps more true but *hors-champs*, or out of reach. It takes plenty of walking back and forth in the room to figure out these twin worlds. You can't get both at once.

Much art from other centuries – Baroque allegories or religious motifs from the Renaissance, say – demands a tremendous amount of knowledge to be fully appreciated; why should today's art be any different? Douglas's most complex installations can certainly be

appreciated on a straightforward level, but for the viewer who is willing to delve deeper, the pieces take on much more significance. Douglas is no obscurantist: his writings are crystal clear, and so is his work. At times it's just so multilayered that the ideal viewer – one who comprehends all the parameters involved – hardly exists. Is that a problem? Take the video installation *Der Sandmann* (1995), an elaborate meditation on the mechanisms of recollection and temporal awareness, and, I believe, one of the most sophisticated works of contemporary art I've come across in recent years. A poetic, visually perplexing attempt to come to grips with the German situation a few years after the fall of the Berlin Wall, the piece can be viewed and enjoyed simply as a dreamlike scenario about the childhood memories of three people from the small, formerly East German city of Potsdam. But to really appreciate the installation requires a familiarity with numerous sources: the German Romantic writer E.T.A. Hoffmann's story "Der Sandmann"; Freud's essay "The Uncanny" and its theory of repetition; as well as certain aspects of German city planning, particularly the *Schrebergärten*, or small plots of land that the poor could lease from the city to grow their own vegetables. These gardens were named after nineteenth-century educator Moritz Schreber, whose son Daniel Paul Schreber's *Memoirs of My Nervous Illness* would play a crucial role in the development of Freud's theory of paranoia. All this is relevant to Douglas's installation, even if it's not ultimately what the work is "about."

Der Sandmann is a double video projection with each screen showing a 360-degree sweep of a Schreber garden. Staged in the old Ufa studios just outside Potsdam and shot on 16mm film, the sets are re-creations of the gardens: one as they might have appeared twenty years ago, the other a contemporary version, partly transformed into a construction site. The most curious aspect of this double projection is the vertical seam that simultaneously sutures and separates the halves. Initially the line appears to be only an irritating distortion, and

even if you concentrate on the seam, it's not easy to understand what it represents or how, technically, it's produced. The gardens occupy their respective spaces to either side of the cleft in such a way that, in Douglas's own words, "as the camera passes the set, the old garden is wiped away by the new one and, later, the new is wiped away by the old; without resolution, endlessly." Thus, the seam is a fissure in time, keeping zones of temporality apart and yet letting them touch via an ultra-thin "split" that marks a kind of syncopation. The two sides are woven together by a story delivered on-screen by Nathanael, the tragic hero of Hoffmann's tale, who reads aloud from a script but moves his lips in a way that doesn't match the words – or so it seems. On closer inspection, it becomes clear that his lips actually do fall into sync at exactly the moment when Nathanael himself passes across the fracture.

As the cameras rotate, the cleft seems to widen so that the objects that enter into it disappear for a moment. Time is eating its way across the screen: things are consumed by the hungry gap but reappear a second or two later on the other side. If the line itself represents the present – the conspicuous yet evasive Now of perception – then this work seems to make a philosophical point about the temporality of experience. Is the present ever present? In fact, everything seems to start with deferral, difference, and delay – in short, with what Jacques Derrida gave the name *differance*. The presentness of perception is not the firm foundation it has been held to be, but an effect of a play of differences – and not just temporal differences. Hoffmann's story is full of doubles, uncanny repetitions, and puzzling correspondences. Given the abundance of optical metaphors in the tale as well as the central theme of the eye and the fear of losing one's sight, it's perfect material for cinematic experiments. But rather than illustrate the story, Douglas puts the central concepts into motion. There are no sliced eyes à la Buñuel or Bataille but a vertical cut that gives rise to a disharmonious cleft through the field

of vision. Yet *Der Sandmann* questions more than the traditional hegemony of vision; it also effectively stages a theory of temporal awareness – a *chronology* – that represents a threat to the understanding of the self as a subject fully present to itself. The work seems to propose a form of temporal awareness that comes close to what Freud understood as *Nachträglichkeit*, or deferred action. Events that have never been given as fully present are experienced only after the fact. In "Freud and the Scene of Writing," Derrida sums it up nicely: "It is thus the delay which is in the beginning."[05]

(This is perhaps the appropriate place to return to the doctrine of the Eternal Return, which a moment ago was given a too simplistic – atomistic – rendering. In an infinite stretch of time, the number of possible permutations is exhausted, and the universe begins to repeat itself, I claimed. But perhaps it's not so much the physical things that must return – historical events, life forms ["… once again you will be born from a belly; once again your skeleton will grow …"] – but that *difference* which is chronos, or time, itself. *Difference as such returns:* the cleft or fissure that is the Now, the syncopation that is "presence" thought to an end. The Eternal Return is, in fact, not the thought that the universe must come back the same, but rather that *difference* is always coming back. *Difference* must be affirmed again in each case as such. In this way, the thought becomes a principle of "selection."[06] Only that which is affirmed returns, and only *he who I am now can will the necessity of my return*. This selective law of time is *a necessity that must be willed*, says Klossowski, chief promoter of Nietzsche's "vicious circle," and announces, obviously animated by a sense of inestimable lightness: "At the moment the Eternal Return

05 JACQUES DERRIDA, *WRITING AND DIFFERENCE*, TRANS. ALAN BASS (CHICAGO: THE UNIVERSITY OF CHICAGO PRESS, 1978), P. 203.

06 GILLES DELEUZE, *NIETZSCHE & PHILOSOPHY*, TRANS. H. TOMLINSON (LONDON: THE ATHLONE PRESS, 1983), PP. 68–71.

is revealed to me, I cease to be myself *hic et nunc* and am suscep-tible to becoming innumerable others, knowing that I shall forget this revelation once I am outside the memory of myself … . And my present consciousness will be established only in the forgetting of my other possible identities."[07] What this means to Bob and Donny – the cyclical protagonists of *Win, Place or Show* – I don't want to know. Nathanael, our fractured hero of *Der Sandmann*, will no doubt rotate eternally, out of sync with himself, and, hence, he perfectly demonstrates the relentless return of difference. "Without resolution, endlessly," says Douglas.)[08]

"The doubt, that pronounal doubt, doubt of pronouns, doubt of the certainty of an I, is the *a priori* of my work," Douglas declared in 1994.[09] The genealogy of the subject is always also a *chronology*. If the self doesn't experience itself in immediate self-proximity but in-stead realizes things about itself only belatedly, as the Freudian theory suggests, then the implications for subjectivity are significant. With its intricate temporal structure, its perplexing chronology, *Der Sand-mann* provides a working model for the historical repetitions that recur, as it were, from work to work. Take *Onomatopoeia* (1985–86), in which a passage from Beethoven's "C Minor Sonata, Opus III" – famously commented on by Theodor W. Adorno and Thomas Mann – is performed by an old player piano, above which are projected images of textile-factory machinery. What is especially intriguing about the Beethoven fragment is its inexplicable resemblance to ragtime music. This accidental connection seems to transplant the *Nachträg-lichkeit* of psychological temporality to the stage of history: a few notes by a nineteenth-century genius apparently realize their full sig-

07 KLOSSOWSKI, P. 58.

08 QUOTED IN SCOTT WATSON, DIANA THATER, CAROL J. CLOVER, *STAN DOUGLAS* (LONDON: PHAIDON, 1998), P. 127.

09 SEE IBID, P. 9 FOR A DISCUSSION ABOUT THE PROBLEMS OF THE FIRST AND THE THIRD PERSONS.

nificance only retroactively, when the industrial mechanization that emerged during the composer's lifetime finally gained a full grip on artistic creativity.

Douglas's historical explorations are always concrete in their scrutiny of technological changes, and he always seems to be in search of situations in which a particular development could have veered off in an alternate direction, where layers of significance are present but not yet activated. The inquiries into constellations of technology, ideology, and art are never pursued in the interest of achieving some overwhelming, all-encompassing final synthesis. On the contrary, most of Douglas's work displays a tragic fracture, a tension that may appear superable in rare hopeful moments but can never be fully redeemed. In *Nu.tka.* (1996), another elaborate installation marked by a tormenting cleft, the sound track is kept out of sync and the shot out of focus until sublime clarity finally arrives in the guise of madness. The distorted projections show the gorgeous coastline of Vancouver Island while two eighteenth-century captains, colonialists who claim the land for England and Spain, respectively, deliver a set of delirious narrations revealing their increasing derangement. In *Le Détroit* (2000), a ghost story about a house that "holds darkness within," two versions of the same 16mm black-and-white film (one standard, the other inverse and in negative), are projected from opposite sides onto a translucent screen. On either side the corresponding version dominates and is distinctly visible but the translucence creates visual effects: both sides appear a bit washed out and grey. The imagery radiates a ghostlike colorless light; it is, one could say, spectral. The two film loops are also a few frames out of synch producing a kind of temporal halo of a few fractions of a second so that every movement is surrounded by a spectral echo or premonition of things to come. This increases the ghostlike quality.

The interest in spectral thought or "spectrology" (a term used by Douglas in his 2002 essay "Suspiria"),[10] recurs in many works, including the 2005 installation *Inconsolable Memories*, a free remake of Tomás Gutiérrez Alea's *Memorias del subdesarrollo* (Memories of underdevelopment) produced in Cuba 1968. In both works, the protagonist is a person who stays behind in Havana during a time when everybody important seems to have left the country. Alea's film is set in 1961–62, a time of Cuban mass emigration; Douglas's protagonist on the other hand is adrift in the same city two decades later during the Mariel Boat Lift when some 100,000 Cubans emigrated. He is arrested for having received a package from abroad. Escaping prison after four years, he tries to find his way back to his old self and into his previous world, but he has turned into a ghost surrounded by individuals that mirror others in an uncanny fashion. Havana itself has turned into a city of doubles. Indeed, the entire work seems to be a study in spectrology: not only does the protagonist mirror the main character in Alea's film (both are named Sergio), but he is also a double of his own earlier self.

Unity is never a given. Works such as *Der Sandmann* and *Le Détroit* both convey a sense of a self that gains (what one might call) self-identity only in rare instances. It would seem that Douglas's work explores the position of the experiencing subject in relation to various technologies and systems of representation, but with the awareness that the construction of subjectivity is an open-ended process. The self emerges not as a closed unit but as a zone of friction where antagonistic forces clash. And it's not always a question of tragic tension and agonizing non-identity: sometimes what emerges is a joyous form of defiance, a determination not to obey. Douglas's early works made for broadcast on Canadian television are more direct than the elaborate installations, but no less mystifying. In *Answering Machine*

10 STAN DOUGLAS, "SUSPIRIA," IN *DOCUMENTA XI* (OSTFILDERN-RUIT: HATJE CANTZ, 2002), P. 557.

(1988), a short piece belonging to the series "Television Spots" (1987–88), a woman is sitting at a table smoking a cigarette when the phone rings. She doesn't answer. In the series "Monodramas" (1991), the viewer is treated to scenes in which something goes astray. In each tiny narrative, some small error – a school bus driving on the wrong side of the road or a person suddenly vanishing without explanation – produces a situation out of the ordinary. One has the sense that the story has just begun and that the question marks will disappear momentarily. But they never do; no explanation arrives. At the core of Douglas's work one finds the problem of the self that is no longer identical to itself, a self that has no natural link to its own voice. It is no surprise that the artist frequently acknowledges the influence of Samuel Beckett, quintessential interrogator of the coherent self and liberator of the voice. The fundamental doubt of pronouns yields awkward and perplexing situations. If the self remains unnameable, then how can we be certain when we name others? In *I'm Not Gary* (1991) two men approach one another on the sidewalk. "Hi Gary," says one of them, and since there's no response, he adds, "How you doing?" They're standing very close; there can't really be a misunderstanding. Then the reply comes: "I'm not Gary."

WHO IS ME TODAY?

Douglas's doubt of pronouns, his fundamental doubt of the certainty of an *I*, is the very point of departure of this essay. Who is speaking, receiving, perceiving? Who is the subject established (constructed, assembled or taken for granted) in the works scrutinized here – these abstract, yet often visceral machineries of time-consciousness, perception, and kinesthetic experience? Can we still characterize the positions here in question through the grammatical "persons" and traditional indexicals of discourse, or are we forced into a kind of neutrality preceding all persons (not yet an *I*, not a *you*, not a *we*, *she* or a *he*), perhaps comparable to the mode of speaking described by poet Lawrence Ferlinghetti as "the fourth person singular"? For instance, in Eija-Liisa Ahtila's early 90-second work *Me/We* (1993), the seemingly natural link between subject and voice has been eliminated so that many voices speak through the same mouth (or the same voice through a multiplicity of mouths). What is the grammatical term best suited to describe such a linguistic predicament? Again, who is speaking? Since the aspiration here is not to conceive a new phenomenology of temporal awareness, let alone a general theory of the subject, the reply (or rather, the replies) to the question of the *Who?* will clearly be less general than in treatises with such aims. But it will, I hope, be more precise and specific. In accordance with a certain lighthearted nominalism, the reply will vary from work of art to work of art. Why? Because "I" am not the same when inhaling the air of precise indifference of Dominique Gonzalez-Foerster, when lost in Eija-Liisa Ahtila's inscrutable catacombs of pastness, when trying to assess the transcendental syncopations of Stan Douglas, when experiencing the polyrhythmic stroll across Doug Aitken's electric earth or the luminous simultaneity of Tobias Rehberger. Ultimately each work needs its own concepts and its own theory. Or rather, each of these works has given rise to its own set of concepts and set them in motion. The work of art *is* this very motion, and to theorize it thus means little more than to make the concepts visible as concepts and to follow closely their itinerary and the modes of subjectivation

involved. From work to work, from configuration to configuration, I am – the "I" is – another. Sometimes "I" is not *one* but *many*.

However, the old credo of a continuous *becoming-other* is not a satisfying result unless it is made more specific. What has inspired me to write this essay is the optimistic idea that the intense sensations associated with these works of art can be described and, at least to a certain extent, analyzed as different instances of becoming a subject. Is it the intentionality described by phenomenology and the ambiguous flesh of the active viewer who enters the work of art and fully explores its most extreme possibilities that determine the limits of possible subjectivation? Or is it the work itself that defines the parameters of new potential forms of subjectivity, perhaps involving modes of awareness that dodge the framework of phenomenology? Such are the questions that constitute the ultimate horizon of this essay.

* * *

Considering the frequent use of phenomenological concepts, it may seem surprising that I suggest a certain form of experimental "constructivism," one that has found inspiration in Walter Benjamin's declaration that the human perceptual apparatus, far from being a natural given, is historically and technologically conditioned. In some of the most progressive and daring essays from the 1930s, Benjamin envisions a new form of subjectivity in sync with the latest technologies of mechanical reproduction – a form of collectivized subject that has left traditional notions of creativity and esthetics behind in order to re-negotiate the function of art in terms of (socialist) politics and new forms of mass-production and distribution. Of this "necessary und ultimately liberating"[11] integration of the human subject with the technology of cinema, Rosalind Krauss writes, "Not only was film to release men and women from the confines of their private spaces and into a collective realm … but it was to infiltrate and restructure subjectivity itself, changing damaged individual experience into energized collective perception."[12] She cites Benjamin, who obviously saw this reconstruction of subjectivity as a moment of emancipation and compared it to the act of breaking out of jail: "Then came film and exploded this prison-world with the dynamite of one-tenth seconds, so that now, in the midst of its far-flung ruins and debris, we calmly embark on adventurous travels."[13] Benjamin's "constructivist" approach toward the question of a future subject – full of optimism and difficult to reconcile with the melancholic gaze and the interest in obsolescence typical of the majority of his writings – bears certain similarities to more recent speculations concerning new constructions of the self, admittedly less collectivistic but carried forward by a

11 ROSALIND KRAUSS, "'THE ROCK': WILLIAM KENTRIDGE'S DRAWINGS FOR PROJECTION," *OCTOBER* 92 (SPRING 2000), P. 30.

12 IBID.

13 WALTER BENJAMIN, "THE WORK OF ART IN THE AGE OF MECHANICAL REPRODUCTION," IN *ILLUMINATIONS*, TRANS. H. ZOHN (NEW YORK: SCHOCKEN BOOKS, 1969), P. 236.

similar rhetoric of liberation. Could one even relate them productively to Deleuze's prophecy of a form of life after Man, a future "fold" or "superfold" dependent upon forces from the *outside* that are emerging in new technologies and systems of communication? Who, then, comes after the subject?[14] Who emerges?

Once we have liberated ourselves from a traditional notion of subjectivity (that of transcendental phenomenology still being the most sophisticated and persuasive), the plurality of positions and the discontinuity of functions seem to open up a spectrum of diverse subject *constructions*, making possible and urgent Claude Morali's question, "Who is me today?"[15] It has never been my ambition to treat artworks

14 AFTER THE SUBJECT COMES NOTHING BUT A MUTILATED SUBJECT, ADORNO WOULD INSIST. THIS STRAIN OF THOUGHT HAS A POWERFUL REPRESENTATIVE TODAY IN BENJAMIN BUCHLOH: "THE NEO-FUTURISTIC MYTH OF INNOVATIVE FORMS OF COMMUNICATION, OF A TECHNOLOGICAL PROGRESS UNDREAMT BY ANY PRIOR GENERATION WITHIN ADVANCED INDUSTRIALIZED CAPITALISM, DELIVERED A UNIVERSALLY GOVERNING TECHNO-SCIENTIFIC PSEUDO-COMPETENCE AS A SUBSTITUTE FOR A LINGUISTIC CONSTITUTION OF THE SELF. BY COLLAPSING EACH AND EVERY ACT OF LINGUISTIC ARTICULATION WITHIN PRE-ESTABLISHED FORMULAIC SYSTEMS THAT EXERTED TOTAL CONTROL AND WERE INEXORABLY LINKED WITH EVER-MORE-TOTALIZING DEMANDS OF CONSUMPTION, THESE SYSTEMS OF CONTROL SEEMINGLY FORECLOSED THE VALIDITY OF ALL OTHER CULTURAL CONVENTIONS." (BENJAMIN BUCHLOH, "RAYMOND PETTIBON: RETURN TO DISORDER AND DISFIGURATION," *OCTOBER* 92, P. 37.) SO ARE ALL RECENT IDEAS OF NEW FORMS OF SUBJECTIVITY EMERGING THROUGH THE INTERACTION WITH NEW TECHNOLOGIES – THOSE DEVELOPED BY DELEUZE, SAY – JUST HYPOCRITICAL MYTHS CONCEALING THE FACT THAT ALL EMANCIPATORY SPACES ARE BEING RAPIDLY ERADICATED BY AN INCREASINGLY MERCILESS GLOBAL SPECTACLE MACHINE INHABITED BY RUTHLESS ENTREPRENEURS, ON THE ONE HAND, AND PHLEGMATIC CONSUMERS, ON THE OTHER, I.E., SOLELY BY PROFOUNDLY MUTILATED SUBJECTS? MAYBE THIS IS THE ONLY THING LEFT TO US. PERHAPS TODAY'S PROFOUNDLY DAMAGED SUBJECTS HAVE NO OTHER OPTION SINCE WE ARE ALL INCAPABLE OF ANY KIND OF TRULY EMANCIPATORY PRACTICE. IF THIS IS THE CASE, THIS ESSAY COULD END HERE WITH A STRING OF APOCALYPTIC STATEMENTS: TIME IS OUT OF JOINT. WE HAVE RUN OUT OF TIME. THIS IS THE END.

15 CLAUDE MORALI, *QUI EST MOI AUJOURD'HUI* (PARIS: FAYARD, 1984).

as illustrations of philosophical doctrines. Rather, I believe that the works explored bring forth their own set of concepts. Each and everyone of these works of art (some of which I dwell on, others mentioned only in passing) represents a productive environment – a heterogeneous apparatus which lets a subject emerge and unfold in accordance with a specific distribution of time and space, be it the hollowing out of an imaginary time in the interstices of fiction that Pierre Huyghe talks of, the temporal polyphonies of Douglas and Rehberger, or the grand mediascapes of Aitken. That the problems of temporality play a crucial role in the attempts to come to grips with these varying concepts of subjectivity can be no mere coincidence considering the instinct of a long line of writers locating the unrest elicited by time at the very heart of the subject. Commenting on the Kantian idea of the "self-affection" of time as the most original form of self-awareness, Maurice Merleau-Ponty concludes, "It is of the essence of time to be not only actual time, or time which flows, but also time which is aware of itself."[16] This turning back of time towards itself, an original temporal fold, traces out an interiority, and represents the very "archetype of the *relationship of self to self*."[17] Can this original form for becoming a subject, this "chronological" figure par excellence, ever be captured visually? Is there such a thing as a "time-image"?

This essay is not an appendix to Deleuze's *Cinema 1–2*, nor is it a bold attempt to a third part, a *Cinema 3*, extending the inquiry into recent post-cinematic experimentation. Why not? Primarily because these sketches break with some of Deleuze's fundamental assumptions, most notably with the explicit Bergsonism that keeps his otherwise rather scattered explorations together so as to constitute one work. The analytical tools here employed come primarily from a diffe-

16 MAURICE MERLEAU-PONTY, *THE PHENOMENOLOGY OF PERCEPTION*, TRANS. C. SMITH (LONDON: ROUTLEDGE, 1962), P. 426.

17 IBID., P. 425.

rent tradition of thought, that of phenomenology. This does not imply that the framework of phenomenology is seen as final. On the contrary, the theoretical concepts are applied in such a fashion that the very limits of phenomenology are tested. Some of the works analyzed here, in fact, seem to drive us beyond phenomenology.

When considering phenomenology *beyond* phenomenology, it has often been pointed out that there is a tension between Husserl's official program, on the one hand, and the concrete analyses of phenomena such as temporal awareness and the problems of alterity, on the other. The rigor of these specific analyses and the precision of the conceptual devices employed make the tension within phenomenology conspicuous. The immediate presence of the constituting subject to itself is not as evident a starting-point as originally believed. This shakes the very foundations of phenomenology, and one must inquire: what is the status of the phenomenological vocabulary if the overall approach is no longer that of a *Grundlegung*? Are these devices – for instance, the technical terms introduced to describe the flow of internal time-consciousness (impression, retention, protention, or primary anticipation) and the distinctions established in order to separate presentational forms of consciousness (perception in the widest sense) from various forms of re-presentation (imagination, recollection, anticipation, empathy, pictorial consciousness, etc.) – still valid as descriptive tools when they are freed from their original foundationalist framework? Phenomenology, one can argue, not only offers us a box of useful descriptive tools, but also provides a path for reflections that break with its own fundamental conditions of possibility. In this essay, Husserl's concepts are not only freed from the general ambitions of his philosophy as a foundational discourse (and thus, one could perhaps say, employed with as much or as little hermeneutical respect for the original philosophical milieu as Deleuze pays to the historical context of Bergson when applying his concepts to films by Resnais, Mankiewicz, and Wells); more specifically, they

are seen as relevant instruments when exploring those *modes of appearance* that should interest anyone for whom the "excessively determined unity of the subject"[18] has become suspect. The emphasis on the temporal (what I here call "chronological") aspects of these modes of appearance of subjectivity will lead us to see the works of art here under scrutiny as so many attempts to capture the very dialectic of time itself, a dialectic that by necessity seems to lead us beyond the temporal – to the "time-less void of an ocean death," described by Tacita Dean or to the infinite folds of a Baroque creation – machine, garden, or textual architecture. At least since Kant, we know that there is no such thing as a straightforward image of the temporal flow (the flow itself being just one of several recurring metaphors). "For all of this, we have no names,"[19] says Husserl about the time-constituting "flow" (*Fluß*) of consciousness which for him coincides with "absolute subjectivity" itself. There are only indirect ways of speaking of this realm, only more or less successful *metaphors* (a concept that becomes problematic once the lack of real proper names is fully acknowledged); more or less effective illustrations: architectural, diagrammatic, symbolic, spatial-kinesthetic, topological. Deleuze's idea of time crystallized into an image must be developed to allow for more intricate forms of schematism. In the end, there are only more or less riveting analogies: the line, the circle,

18 SEE MAURICE BLANCHOT, "MICHAEL FOUCAULT AS I IMAGINE HIM," IN FOUCAULT/BLANCHOT, TRANS. J. MEHLMAN (NEW YORK: ZONE BOOKS, 1987), P. 76: "THE SUBJECT DOES NOT DISAPPEAR; RATHER ITS EXCESSIVELY DETERMINED UNITY IS PUT IN QUESTION. WHAT AROUSES INTEREST AND INQUIRY IS ITS DISAPPEARANCE (THAT IS, THE NEW MANNER OF BEING WHICH DISAPPEARANCE IS), OR RATHER ITS DISPERSAL, WHICH DOES NOT ANNIHILATE IT BUT OFFERS US, OUT OF IT, NO MORE THAN A PLURALITY OF POSITIONS AND A DISCONTINUITY OF FUNCTIONS (AND HERE WE REENCOUNTER THE *SYSTEM OF DISCONTINUITIES*, WHICH, RIGHTLY OR WRONGLY, SEEMED AT ONE TIME TO BE CHARACTERISTIC OF SERIAL MUSIC)."

19 EDMUND HUSSERL, *ON THE PHENOMENOLOGY OF THE CONSCIOUSNESS OF INTERNAL TIME (1893-1917)*, TRANS. J. B. BROUGH (DORDRECHT/BOSTON/LONDON: KLUWER), 1991, P. 382.

the cone, the pyramid, the crystal, the spiral, the network, the fold, the labyrinth.... This is the perspective from which the works of art here are scrutinized. *Chronology*, accordingly, is never to be thought of in the singular. One would perhaps have to conclude (in analogy with Wittgenstein's comment on phenomenology): there is no chronology, only chronological problems,[20] and they are related not only to the issue of temporality as such and to our various modes of relating to time, but also to the very issue of what it means to be a subject.

(If there is a closeness here to Deleuze's thoughts on time, then it is primarily to those very late attempts to bring Foucault's theories of subjectivation closer to phenomenological terminology and to the topologies of transcendental philosophy: "Time becomes a subject because it is the folding of the outside and, as such, forces every present into forgetting, but preserves the whole of the past within memory: forgetting is the impossibility of return, and memory is the necessity of renewal."[21] The ultimate exteriority, the absolute Outside, can no longer be understood in spatial terms, but rather as a temporal dimension: "For a long time Foucault thought of the outside as being an ultimate spatiality that was deeper than time; but in his late works he offers the possibility once more of putting time on the outside and thinking of the outside as being time, conditioned by the fold."[22] Time affects itself, and through this auto-affection it folds and creates an interiority, a realm of reflexivity. Thus, an Outside is "twisted," "folded," and "doubled" so as to create an Inside. Is there perhaps another possible form of folding after the subject? A fold (or "superfold") after Man? If there is, Deleuze maintains, then time is still its medium. In that sense, we remain, even here, within the realm

20 LUDWIG WITTGENSTEIN, *BEMERKUNGEN ÜBER DIE FARBEN/REMARKS ON COLOUR* (OXFORD: BASIL BLACKWELL, 1977), §53.

21 GILLES DELEUZE, *FOUCAULT*, TRANS. S. HAND (LONDON AND NEW YORK: CONTINUUM, 1988), P. 108.

22 IBID.

of temporal architectures and topologies. We remain within the realm
explored by chronology.)

CRYSTALS

The past is present. Something has happened and the echoes are still resonating in my head. They are not becoming more difficult to discern; in fact the echoes are becoming increasingly loud and impossible to escape. The past lingers on, yesterday reverberates in today. An example: a teenage girl with short blond hair is throwing a ball against a wall. A man is sobbing heavily in a bedroom nearby; suddenly he screams out in agony. A girl's voice explains: "Today my dad is crying. Late last night a car drove over his dad who died instantly." These ominous opening words set the tone in Eija-Liisa Ahtila's *Today* (1996/97), a three-part work that presents the same violent incident seen through the eyes of three different characters: a young girl, a grown-up man, and an elderly woman. Their fragmented, strangely poetic reports touch upon the accident, but simultaneously weave a dense web of questions concerning family relationships, personal identity, sexuality, and death.

The past is present. Something has happened: an accident, a catastrophe, a tragic event. The work unfolds as a process of assessing and working through – a process of grieving that consists of fragments of narration incapable of presenting an overarching and coherent account. This is true of *Today* and *Consolation Service* (2000), and in one way or another of all of Ahtila's mature works. "It's a story about an ending," says the neighbor-narrator in *Consolation Service*. There is no therapy, no catharsis, no Hegelian *Aufhebung*. It all starts with an ending, and then it ends again. This is Ahtila's grim idea of consolation.

It is true that the narrative does not proceed according to "simple causality," but what then has taken its place? There is a recurring temporal structure in Ahtila's films and installations which all seem to depend on the notion of the secret that lingers in the past. As viewers we are plunged into a situation that is incomprehensible if we do not take the echoes of the past into account. Something of great

magnitude – a rupture, a catastrophe, an unbearable moment of truth – has happened, and it appears to be our task to come to terms with this traumatic *thing*. The work is a kind of interpretative or even cathartic ritual which might lead to the past being exorcised. Perhaps the ceremony can even serve as the starting point for the reconstruction of a full and self-identical subject? Ahtila's works suggest such a possibility, but the full reconstruction is deferred and remains a promise that cannot be fully kept. The wounds and the mystifying fractures in the past remain more strongly felt than any sense of a harmonious self-identity.

Nabokov writes: "Perhaps if the future existed, concretely and individually, as something that could be discerned by a better brain, the past would not be so seductive: its demands would be balanced by those of the future."[23] This would hinder us from constantly sinking into the history of things. He adds, "But the future has no such reality (as the pictured past and the perceived present possess); the future is but a figment of speech, a specter of thought." The seductiveness of the past has led many philosophers, among them Husserl and Bergson, to treat the past and the future in an asymmetrical fashion, paying a great deal more attention to that which has been and to our capacity to retain it. Ahtila is an artist who, in a comparable way, seems to care primarily about the past. It is a past that is alive and which creates considerable turbulence in the present. A typical feature of Ahtila's work which is quite salient in *Today* is the speed and nervousness with which the protagonists deliver their lines. There is something hectic and impatient about these voices. What is it that creates this sense of urgency? Maybe it's the strife against the ruthless power of oblivion. Her stories can be seen as a fight against forgetting, and this is perhaps what creates the feeling of urgency in her work. We obviously have no time to lose. How can we characte-

23 VLADIMIR NABOKOV, *TRANSPARENT THINGS* (NEW YORK: VINTAGE, 1972), P. 1.

rize the result of Ahtila's creative effort? Obviously, the past that we are trying to come to terms with is constantly slipping further away, and no final secret is ever revealed. Hers is an analytic of finitude that lets a retreating origin return according to rules that have already been set in such a way that no overarching narrative appears to give coherence to fragments of a scattered life. Only in brief moments does transformation seem possible, and the change does not concern the past itself but rather our relationship to alterity in all its forms: the past, our own and that of others, and the otherness that exists within ourselves. What is the act of consciousness in question – reminiscence, self-analysis, a process of grieving or a paradoxical celebration of that which has been?

The dead old man appears in the recollections of the young man in pain. He emerges out of the darkness, walking on a road that runs through a forest. The trees cast shadows across the road producing a geometrical pattern of light and darkness. The man comes closer; he looks directly at us, the viewers. Then he turns away and lies down on the road in such a fashion that the body disappears into one of the shadows, with only the arms visible. Then he pulls them closer to his body, and he is gone entirely. We understand what will happen, or rather, what has already happened: "We drove for a swim through the forest – where the road is striped with black shadows of the trees. Suddenly one of those shadows stood up … ." That image of a man lying down to die, pulling in his arms and vanishing into darkness: an image in which time seems to crystallize. It's a kind of memory, yet he is very much there, preparing himself for a future of no return. Past, present, future in the blink of an eye, Ahtila's works are full of dense and temporally complex images. In his book on the "time-image," Deleuze analyzes exactly these kinds of condensed cinematic moments that seem to capture the very movement of temporality in a crystallized formation:

WHAT CONSTITUTES THE CRYSTAL-IMAGE IS THE MOST FUNDAMENTAL OPERATION OF TIME: SINCE THE PAST IS CONSTITUTED NOT AFTER THE PRESENT THAT IT WAS BUT AT THE SAME TIME, TIME HAS TO SPLIT ITSELF IN TWO AT EACH MOMENT AS PRESENT AND PAST, WHICH DIFFER FROM EACH OTHER IN NATURE, OR, WHAT AMOUNTS TO THE SAME THING, IT HAS TO SPLIT THE PRESENT IN TWO HET-EROGENEOUS DIRECTIONS, ONE OF WHICH IS LAUNCHED TOWARDS THE FUTURE WHILE THE OTHER FALLS INTO THE PAST. TIME HAS TO SPLIT AT THE SAME TIME AS IT SETS ITSELF OUT OR UNROLLS ITSELF: IT SPLITS IN TWO DISSYMMETRICAL JETS, ONE OF WHICH MAKES ALL THE PRESENT PASS ON, WHILE THE OTHER PRESERVES ALL THE PAST. TIME CONSISTS OF THIS SPLIT, AND IT IS THIS, IT IS TIME, THAT WE SEE IN THE CRYSTAL.[24]

Deleuze conceives of temporality in Bergson's terms, and to a certain extent his entire study of the cinema is as much a philosophy of time and movement as it is an interpretation of certain artworks using moving images. What is Bergson's philosophy of time all about? Deleuze presents the most basic ideas: "Bergson's major theses on time are as follows: the past coexists with the present that it has been; the past is preserved in itself, as past in general (non-chrono-logical); at each moment time splits itself into present and past, present that passes and past which is preserved."[25] Time flows and each present fades, but it doesn't disappear. It is preserved as past and consciousness has direct access to this past. The time-images of cinematic imagination that succeed in making this temporal struc-ture evident in forcing themselves upon the viewer are the points of crystallization: "The crystal-image was not time, but we see time in the crystal. We see in the crystal the perpetual foundation of time."[26] Deleuze's philosophical starting point is Bergson rather than Husserl, who, in my view, developed an even richer approach to the problems of time-consciousness. Like Bergson, Husserl considers temporality

24 GILLES DELEUZE, *CINEMA 2: THE TIME-IMAGE*, TRANS. H. TOMLINSON AND R. GALETA (MINNEAPOLIS: UNIVERSITY OF MINNESOTA PRESS, 1989), P. 81.

25 IBID., P. 82.

26 IBID., P. 81.

to be the most basic level of subjectivity. And like Bergson, he distinguishes between different kinds of past time and the different capacities the subject has of relating to it: the recent past which is still given in immediate proximity to the ongoing perceptual flow, and the past which has already faded into oblivion and, therefore, needs a special act of recollection to become present again. The first kind of memory, of the most recent past, Husserl calls retention; the second form he calls recollection. In our conscious life, Husserl would say, we are continuously split between several "tracks" of awareness: we live in the perceptual presence – which is built up by impression, retention, and protention (expectation) – as well as in the recollected past. In addition to this, other forms of awareness, such as empathy and imagination, make the machinery of consciousness even more complex. The mind is a multi-channel apparatus, and several programs are active and viewed at the same time. When a contemporary artist such as Douglas talks of "temporal polyphony" in relation to his split-screen installations, and more specifically *Der Sandmann*, it may sound like a very advanced form of consciousness:

BEING ABLE TO SIMULTANEOUSLY PRODUCE DISTINCT VOICES HAS ALWAYS BEEN SOMETHING I'VE BEEN TRYING TO ACHIEVE, NOT ALWAYS HAVING THIS IDEA OF A SINGLE, STATIC IDENTITY BUT ONE WHICH IS ALWAYS CHALLENGED FROM THE OUTSIDE, AND IS ABLE TO THINK OF 'THE OTHER' SIMULTANEOUSLY. POLYPHONY IS A TECHNIQUE FOR DOING THAT. THAT IS THE FEELING OF *THE SANDMAN*, WHERE YOU'RE SEEING TWO TEMPORAL MOMENTS AT THE SAME TIME, AND YOU'RE HOPEFULLY ABLE TO THINK OF THOSE MOMENTS AT THE SAME TIME, JUST AS ONE IS ABLE TO LOOK AT THE PRESENT AND UNDERSTAND HOW THE PAST LIVED THE WAY IT DID.[27]

In fact, such "temporal polyphony" is the mental state in which we all live continuously, and there are more complicated forms of synchronicity than the mere interplay of perception and recollection. As Husserlian phenomenology makes clear, the nested structure of sub-

27 CITED IN ROBERT STORR, "STAN DOUGLAS: L'ALIÉNATION ET LA PROXIMITÉ," *ART PRESS* 262 (2000).

jectivity allows for many flows of awareness: while looking out of the train window seeing the landscape pass by, I may fantasize about a memory of a strange dream-image or I may remember an old day-dream. The subject – what Husserl calls the ego – is what keeps all the levels of such a multidimensional structure together: "I am always in the present and still in the past, and already in the future. I'm always here and also elsewhere. I as ego come in between these two modes. I am only in this doubling, and I emerge in this displacement."[28]

What happens if the unifying function of the ego is no longer active and the multiplicity of flows live their own autonomous lives? Phenomenological philosophy has taken great pain in analyzing the various illusions produced if one kind of consciousness is mistaken for another, if, for instance, a memory or fantasy is taken for a kind of perception. If, on the other hand, the structuring function of the ego is removed entirely, and each "track" runs independently of the others, it is clearly a question of a severe breakdown of the mental apparatus as a whole. This is madness. Ahtila has characterized her three-screen video installation *The House* (2002) as an account of psychosis. And concerning her work *Anne, Aki, and God* (1998), she writes:

AKI V RESIGNED FROM HIS WORK IN COMPUTER APPLICATION SUPPORT WITH NOKIA VIRTUALS, BE-CAME ILL WITH SCHIZOPHRENIA AND ISOLATED HIMSELF IN HIS ONE ROOM FLAT. HIS MIND STARTED TO PRODUCE A REALITY OF ITS OWN IN SOUNDS AND VISIONS. LITTLE BY LITTLE THIS FICTION BE-CAME FLESH AND BLOOD, THE LINE BETWEEN REALITY AND IMAGINATION BECAME BLURRED. FANTA-SIZED PERSONS AND EVENTS STEPPED OUT OF AKI V'S HEAD AND BECAME PARALLEL WITH THE REALITY AROUND HIM.[29]

28 ROBERT SOKOLOWSKI, "DISPLACEMENT AND IDENTITY IN HUSSERL'S PHENOMENOLOGY," IN *HUSSERL-AUSGABE UND HUSSERL-FORSCHUNG*, ED. S. IJSSELING (DORDRECHT/BOSTON/LONDON: KLUWER, 1990), P. 180.

29 AHTILA, "ANNE, AKI, AND GOD," IN *EIJA-LIISA AHTILA* (KASSEL: FRIDERICIANUM, 1998). ALL AHTILA QUOTATIONS ARE FROM THIS PUBLICATION IF NOT OTHERWISE INDICATED.

This installation, consisting of five monitors and two screens, differs from the works for split-screen installations such as *Today* and *Consolation Service* in that the multi-dimensionality clearly transcends what the viewer can apprehend. Through their speed and complexity, all of Ahtila's works explore the limits of perception, but *Anne, Aki, and God* pushes things further and clearly represents a kind of mental disintegration. The work is an intricate mix of insane imagination and documentary footage. The story, according to Ahtila, is "based on real events about a man who, being in a state of psychosis, created a woman for himself." On the one hand, Aki appears as a confusing multiplicity of faces and voices that deliver the same lines about an ideal woman: "In the daytime, Anne is an aerobics instructor. She is very affectionate by nature, yet firm when necessary." On the other hand, documentary footage is presented showing real interviews with a large number of young Finnish women applying to play the role of Aki's imaginary girlfriend. Thus, everyday reality is presented side by side with fictional, hallucinatory imagery. A third component, present on an additional screen, is an image of God, played by two actors, one female, the other male. Together these elements produce a multi-layered and mazelike narrative, or rather a maze of narratives, that transgresses the mental capacities not only of so-called normality but more radically, keeping the presence of a God in mind, of finite subjectivity. The heterogeneous crystallization of time that takes place here is no longer that of ordinary human experience but that of a shattered consciousness opening up to infinity.

The combination of documentary and fictional narrative in *Anne, Aki, and God* is, to a certain extent, reminiscent of the earlier work *If 6 was 9* (1995), a split-screen installation about the sexual world of young females in Helsinki. The story and the dialogue in this strangely melodious work are fictional, but research and interviews with real people preceded the realization of the work. Ahtila explains the structure of the installation:

If the work about the psychotic telecommunication engineer Aki re-presents the breakdown of normal time-consciousness, then what this portrait of a group of young females conveys instead is a fluid kind of temporality. The three screens display the sexual fantasies, everyday actions, and dreams of the adolescent girls. Even if the work is ultimately a piece of complex fiction, the straightforwardness of the girls creates a strong documentary feel. The intricate interweaving of different kinds of consciousness – memories, fantasies, perceptions – produces not a sense of dissonance, but rather a sense of harmonious flow. The tender lyricism of daydreams and soft piano music clashes with the straightforwardness of their accounts. However, the directness of their stories does not exclude a sense of wonder and mystery: "It was equally amazing to see in a porno magazine that men have no hole behind the testicles. I thought that it had not always been like this."

If cinema could produce what Deleuze calls crystal-images captur-ing the structure of time itself, then the temporal possibilities of the "other cinema," to use Raymond Bellour's concept, i.e., the multi-screen installations of today's artists exploring new forms of narration and synchronicity, are even richer. The simultaneity of several flows of moving imagery grants the possibility not only of crystal-images, but also of more intricate constellations and juxtapositions. Is it the phenomenology of the experiencing subject that interests Ahtila, or is this experiential multidimensionality only a means to an end that

must be described in quite different terms? Clearly there are recurring themes – such as death, dogs, sex and violent desire – that create the strange atmospheres and specific poetry in Ahtila's work, from the early works for monitor to *The Hour of Prayer* (2005), a piece about the death of her dog. But it seems that the phenomenological issues are also of great importance to her. In a recent interview, she talks about her investigations into the functioning of memory and perception:

ONE MORNING WHILE I WAS BRUSHING MY TEETH, I WENT FROM THE BATHROOM TO THE WINDOW AND I SAW A DOG RUNNING ON THE GROUND. I RETURNED TO THE BATHROOM AND THOUGHT ABOUT THE DOG, AND I REALIZED I DID NOT PICTURE IT IN MY HEAD AS I SAW IT JUST A COUPLE OF SECONDS AGO FROM HIGH ABOVE, BUT AS IF I WAS STANDING BESIDE IT IN THE PARK. I SAW IT AS A MEDIUM SHOT FROM THE SIDE, TAKEN FROM MY EYE LEVEL OR EVEN BELOW – IN OTHER WORDS, HOW I HAD SEEN DOGS BEFORE. THAT WAS HOW I RECOGNIZED IT. THIS RELATES TO WHAT I TRY TO DO IN MY FILMS, TO BREAK UP THE SPACE, TO CREATE A SPACE THAT DOESN'T EXIST AT A CONSCIOUS LEVEL.[30]

The richness of temporal experience and the complexity of the experiencing subject is certainly one of the issues explored in Ahtila's mature installations. But already in her three 90-second works for monitor, *Me/We*, *Okay*, and *Gray* (1993), she staged incredibly subtle situations involving fluid and destabilized forms of subjectivity. In these compact and enigmatic works, the natural link between human subject and human voice has been loosened – or entirely eliminated. Here, many voices speak through the same mouth, or the same voice through many mouths. The persons appearing to us in these dense works are alienated not only from the people surrounding them – family, partners, etc. – but even more dramatically from themselves. Alterity, in various forms, seems to rule completely; no harmonious

30 MAGDALENA MALM, "THE IDEA OF LINEARITY BOTHERS ME: AN INTERVIEW WITH EIJA-LIISA AHTILA," IN *BLACK BOX ILLUMINATED*, EDS. SARA ARRHENIUS, MAGDALENA MALM, CRISTINA RICUPERO (LUND: PROPEXUS, 2003), P. 69.

whole or fixed self-identity is in view. There is always a fracture, a split or a dissonance that divides and estranges the speaking subject from itself. Having the actor step out of character and address the audience directly is one of the devices that Ahtila uses to create this alterity effect, but even more subtle is the constant manipulation of the relation between subject and voice. In the humorous *Me/We*, all the members of the family move their lips, but strangely enough it's the self-absorbed father who analyzes the deteriorating family. In *Okay*, a woman walks back and forth in her room, like a nervous animal in a cage, spitting out information about a violent sexual relationship: "If I could, I would transform myself into a dog, and I would bark and bite everything that moves. Woof, woof!" The story is told in the first person, but many voices – male as well as female – are forced upon us. All this happens with such speed and ease that it is impossible to reconstruct the alterations and shifts after viewing the work even a few times. In *Gray* – yet another account of a catastrophe – three women ride in an industrial elevator. They deliver a deeply disturbing report about an imminent environmental disaster. Or maybe it has already happened. They speak with incredible speed about chemicals and radiation, creating a weird poetry: "Lead protects us from gamma-rays, sand stuffs the holes and absorbs the products of fission. All the sounds of comfort are insufficient. One hundred rads equal one gray." The subject emerges in these compact pieces as a preliminary configuration rather than as a substance or essence given once and for all. The subject here is a fluid arrangement of positions that can be redefined and restructured. In Ahtila's works, the subject not only seems to live in time but also to be time. Time itself – a zone of radical difference – can crystallize in many ways but it will never rest in stable self-identity.

CHRONOLOGIES

Kant says that time has only one dimension. It is the form of our inner intuition and as such lacks visually discernable contours. It has no evident shape – *Gestalt* – but we produce our own images of time through various analogies. We borrow models from geometry to get a better grasp of time's inner workings. Thus, we represent time as an infinite line, and from this image we then draw conclusions concerning its nature. A line, as is well known, can be divided into an infinite number of points, and, hence, linear time is haunted by all the riddles known from the inquiries into the concept of movement, for instance that most famous paradox associated with a certain Zeno: Achilles runs ten times faster than the tortoise and gives the animal a headstart of ten meters. He runs those ten meters, the tortoise one; he runs that meter, the tortoise a decimeter; he runs that decimeter, the tortoise a centimeter; he runs a centimeter, the tortoise a millimeter; our fleet-footed hero runs that millimeter, the tortoise a tenth of a millimeter, and so on to infinity, without the tortoise ever being overtaken. A similar paradox is phrased by William James when – in *Some Problems of Philosophy* (1911) – he denies that fourteen minutes can pass. Why? Because first it is necessary for seven to pass, and before the seven, three and a half, and before the three and a half, a minute and three quarters, and so on until the end, the invisible end, through tenuous labyrinths of time. Is there in fact an end? Does the maze have a center?

Commenting on the phenomenological conception of time, more precisely on Husserl's famous diagram showing the series of now-points sinking into the past, Maurice Merleau-Ponty contends critically, "Time is not a line but a network of intentionalities."[31] On the other hand, Jorge Luis Borges, the most severe of all critics of linearity, says, "I know of one Greek labyrinth which is a single straight line." And he adds, "Along that line so many philosophers have lost themselves …"[32]

31 MERLEAU-PONTY, P. 479.

So let's take a closer look at one version of the line:

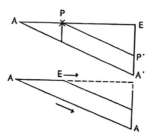

33

J. G. Ballard defined phenomenology as "the central nervous system's brave gamble that it exists."[34] Francisco Varela, the neurophenomenologist, has improved on the Husserlian schema in order to further emphasize the "network" quality of the intentionalities involved. Instead of the classical diagram, he suggests the following rendering, which no doubt leads to a new conception of subjective unity, since the scattered character of the retentions forces us to substitute other metaphors (a tree, a meshwork, forking paths, the river delta or the rhizome) for Husserl's image of a comet's tail.

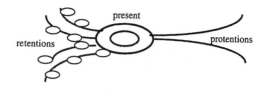

35

32 JORGE LUIS BORGES, *LABYRINTHS* (LONDON: PENGUIN, 1970), P. 117.

33 SEE HUSSERL, §10 FOR A DISCUSSION OF THE DIAGRAM.

34 J. G. BALLARD, *A USER'S GUIDE TO THE MILLENIUM* (NEW YORK: PICADOR, 1996), P. 227.

As shown in Husserl's diagram, every now-point is succeeded by new now-points, creating a series represented by the line AE. Every experience has its beginning in the "source-point" of impression, but immediately starts sinking downwards into pastness. The impression (represented by P), for instance, sinks down along the line PP', and by the time E is experienced in the mode of the now, i.e., as an impression, P has been modified to P'. The sinking down into pastness of retention is not a disappearance into oblivion. On the contrary, Husserl's model accounts for the fact that the elapsing phases are not absent from the scene of consciousness but retained as being past. He is not surreptitiously trying to transform what is past into something present. The retention is not a picture, an after-image or an echo, i.e., a presence signaling in a mediated way something that is absent. The groundbreaking aspect of Husserl's phenomenology of time-consciousness is its attempt to extend the concept of presentation – perception in the widest sense – beyond what is given in the now. In order to grasp the Husserlian notion of presentation, it is important to understand the distinction between presentational and re-presentational consciousness:

PERCEPTION IN THIS CASE IS THE ACT THAT PLACES SOMETHING BEFORE OUR EYES AS THE THING ITSELF, THE ACT THAT ORIGINALLY CONSTITUTES THE OBJECT. ITS OPPOSITE IS *RE-PRESENTATION* (*VERGEGENWÄRTIGUNG, RE-PRÄSENTATION*), UNDERSTOOD AS THE ACT THAT DOES NOT PLACE ITSELF BEFORE OUR EYES, BUT JUST RE-PRESENTS IT.[36]

What is original in Husserl is the way he distinguishes between presentation and re-presentation. Concerning our experience of the past, the line is not drawn between the now-impression, on the one

35 FRANCISCO VARELA, "THE SPECIOUS PRESENT: A NEUROPHENOMENOLOGY OF TIME CONSCIOUSNESS," IN *NATURALIZING PHENOMENOLOGY: ISSUES IN CONTEMPORARY PHENOMENOLOGY AND COGNITIVE SCIENCE*, EDS. J. PETITOT ET AL. (STANFORD: STANFORD UNIVERSITY PRESS, 1999), PP. 266–329.
36 HUSSERL, P. 43.

hand, and memory, on the other, but between two different forms of the latter: retention and recollection. Only what has been presented (through impression, retention, and protention) can be re-presented through acts such as recollection. The sinking down into pastness illustrated in the diagram is all within the realm of presentation (and since there is no a priori limitation to the field of retention one could even inquire why anyone ever forgets anything. What is flowing is not really the temporal modes themselves (past, present, future) but rather the consciousness of these modes. The flow itself is nothing but the continuous anticipation of protentional consciousness and the sinking of impression into retention. And yet, if there really is such a flow at the very foundation of subjectivity, how do we gain knowledge of it? Husserl insists that the flow not only makes possible the appearance of objects in time; it also appears to itself. The most fundamental form of self-consciousness takes place on this plane: the theory of the subject is by necessity also a theory of time. Phenomenology at its most fundamental level is chronology. On the level of the absolute flow, the "constituting and constituted coincide, and yet naturally they cannot coincide in every respect."[37] This means that the flow appears to itself (it is "self-constituting," according to Husserl), but never in the point-like self-presence of a now. Thus, the flow appears to itself in accordance with an essential delay. The primal impression does not appear to itself as impression, but is given only post-factually (nachträglich) through the sinking of impression into retention. This transcendental syncope – similar to the one we encountered in the reading of Douglas's Der Sandmann – implies a serious disturbance of the complete self-immediacy of the subject understood in Cartesian terms. The subject here appears as fractured. According to an inevitable inner chronology, I appear to myself as always already past.

◀

37 HUSSERL, P. 83.

Husserl's theory of a constituting subject emphasizes that the ego it-self is never to be found in the world of objects. The subject is not a thing; it constitutes the world of things that appear in space and time but is itself not located in the world. In this sense, the subject is the limit of the world (it's not in the world but not in some other world either.) This implies that the vocabulary we use when describing things happening in our temporal world is not valid for the level of the "absolute flow." So are we condemned to silence about the nature of the flow? Husserl does not think so, because we can name the flow indirectly through the employment of metaphors: "We have no alternative here but to say: this flow is something we speak of *in conformity with what is constituted*, but it is not 'something in objec-tive time.' It is *absolute subjectivity* …".[38] Even the concept "flow," says Husserl, is a metaphor. Other thinkers have developed other metaphors to capture the inner workings of time. There are only more or less convincing analogies: the point and the line (Aristotle, Kant); the circle or spiral (Hegel, Nietzsche); the cone and the pyr-amid (Bergson); the network (Merleau-Ponty); the gift (Heidegger); the crystal and the fold (Deleuze); the labyrinth (Borges); the Chinese roof (François Julien).[39] These are all versions of chronology. The successive nature of all language makes it impossible for us to talk about things that are not temporal, as Borges points out in his "His-tory of Eternity." Husserl's dilemma is similar. There is no language that can describe the level of transcendental subjectivity, since even the temporal order that we take for granted is constituted on this lev-el. The "flow" is not in time – it is not *temporal* but *temporalizing*. It is not *in* time; rather, it makes the experience of time possible. If one

38 HUSSERL, P. 371.

39 SEE CHAPTER TWO OF FRANÇOIS JULIEN'S *DU 'TEMPS.' ELEMENT D'UNE PHILOSOPHIE DU VIVRE* (PARIS: EDITION GRASSET & FASQUELLE, 2001), FOR A DISCUSSION OF THE NOTION OF *YU-ZHOU*, THE TWO PARTS OF A TRADITIONAL ROOF, AND ITS RELEVANCE FOR A CHINESE UNDERSTANDING OF TIME AND SPACE.

pursues the concept of time to its origin, it ceases to display temporal properties. Husserl gives the "origin" a name that in the end must be understood as one further metaphor: the "living present." Every attempt to categorize it in terms of "events," "processes," and "phases" is a kind of reification and hence a falsification. A true phenomenology of time, a true *chronology*, is aware of its own limitations and ultimately of it own futility as a doctrine.

EXTENDED CINEMA

A married couple, both truck drivers, spend night and day in the same vehicle, traveling across the American continent. While one drives, the other tries to get some rest. The woman prefers driving at night; the roads are empty, and an extraordinary change takes place. Each night the landscape is as if transformed into a film playing on the large windshield of the truck. The wheels are like the reels of a film projector, and in the driver's seat, this magical cinema's sole viewer can enjoy in splendid isolation the spectacle of thoughts and memories on the "windscreen." Doug Aitken – who met this couple at a diner in California – told me about this nocturnal metamorphosis, and it struck me that similar shifts happen in his own works. Take the early video piece *inflection* (1992), which was produced by launching a film camera (attached to a small, high-powered rocket) into the sky. Here, essential elements of Aitken's work are already present: a moving vehicle; speed made tangible; an abstract landscape unfolding through contemporary technologies of vision. Initially one sees the blue of the sky, then the white rocket's elegant slim body. As it takes off, the camera is turned downwards, registering the texture of the ground. It takes a while to understand that the grainy surface is the asphalt where the launch took place, but then things become clear: a parking lot, a few cars, some buildings, a highway. The camera spirals into the sky. Each time it spins we witness the same constellation of buildings and roads … only the cars have moved, and everything is smaller and further away as the ground map expands. When exhibited, the film (transferred to video) is played in extreme slow motion. Frame by frame the urban landscape of southern California unfolds before our eyes: the ordinary features of the suburban grid appear as an enigmatic pattern.

The landscape as seen from a moving vehicle recurs as a theme throughout his works. In *autumn* (1994), the view of the clouds from an airplane window returns several times as an interval of sublime stillness. The wing and the jet engine seem to stand still; the distant

landscape of clouds moves with glacial slowness. Other vehicles make their appearance: a car, a bicycle, a human body. Everything moves smoothly, glides, and drifts in perfect sync, as in a music video liberated from all restrictions and free to concentrate only on ambience and flow. From the very beginning, Aitken's works have referenced speed and motion. This links his endeavors to an older generation of Californian artists interested in aviation and cars, from James Turrell and Chris Burden to Robert Irwin. The experience of driving on a Californian freeway – the feeling of freedom and the pleasure of frictionless motion – has found many expressions, among them Irwin's jubilant report after returning to Los Angeles from a trip to Japan:

I WAS DRIVING OVER MULHOLLAND PASS ON THE SAN DIEGO FREEWAY, YOU KNOW, MIDDLE OF NO-WHERE AT ABOUT TWO O'CLOCK IN THE MORNING, WHEN I JUST GOT LIKE THESE WAVES – LITERALLY, I MEAN I NEVER HAD A FEELING QUITE LIKE IT – JUST WAVES OF WELL-BEING. JUST TINGLING. IT'S LIKE I REALLY KNEW WHO I WAS, WHO I AM … . TO RIDE AROUND IN A CAR IN LOS ANGELES HAS BECOME ONE OF MY GREAT PLEASURES.[40]

Aitken belongs to perhaps a less euphoric generation, but the sensation of driving a car and the experience of moving in vehicles is no doubt of importance for his art, as is the very concept of speed. Another unmistakably Californian project, in many ways related to *inflection*, is the high-speed video *fury eyes* (1994) which documents daredevil Ron Fringer's attempt to drive a motorcycle down a race-track at 190 miles per hour. However, the camera attached to the vehicle breaks down before full speed is reached. Instead of a transcendence of motion hoped for by a whole tradition of predominantly male artists, a technological disruption sets in. Unlike Chris Burden's playful *B-Car* (1975), say, most of the motorized vehicles in Aitken's

40 ROBERT IRWIN, CITED IN LAWRENCE WESCHLER, *SEEING IS FORGETTING THE NAME OF THE THING ONE SEES* (BERKELEY: UNIVERSITY OF CALIFORNIA PRESS, 1982), P. 4.

videos belong to a post-mechanical era and will inevitably collapse. It would appear that it's only their disintegration that comes close to expressing what the artist, in many of his works, is trying to capture: a rich sense of time and narrative structures elaborate enough to give expression to heterogeneity and complexity. In a world where tele-presence and tele-robotics are no longer just the ingredients of science fiction novels or utopian visions but features taken for granted in our everyday lives, the very concepts of place, movement, and velocity must be renegotiated. In the global omnipresence produced by today's digital technologies, experienced time no longer follows a linear order of successive moments. Rather, it becomes, in the words of Paul Virilio, "a system of representation of a physical world where future, present, and past become interlined figures of underexposure, exposure, and overexposure."[41] For more than a decade, Aitken's works have systematically explored the perceptual, narrative, and poetic possibilities opened up by the global environment produced by new technologies of communication. In a world brimming with digital information, we have moved beyond the age when machines are seen primarily as extensions of the muscular system. Today's technologies are methods of extending the nervous system beyond the traditional confines of the human body. They seem capable of altering the very core of experience – the perception of a continuous flow of events across time.

The conventional conception of time in the Western tradition, in science as well as in philosophy, has been that of a line of now-points. The recurring images for illustrating the structure of temporality – from Aristotle's *Physics* all the way to Husserl's phenomenology of time-consciousness – is that of the point and the line. Husserl's famous metaphor, as pointed out above, is that of the comet's tail: what is present in the strict sense is the burning comet itself; whereas the

41 PAUL VIRILIO, *POLAR INERTIA* (LONDON: SAGE, 2000), P. 38.

past, seen as a long series of now-points gone by, makes up the radiant tail which tapers into invisibility and finally oblivion. The idea of a moving body – be it a comet, a truck or a high-powered model rocket functioning as an illustration of time is, it seems, as old as the very concept of linear time itself. But this linear notion of temporality is also something that some thinkers as well as artists have endeavored to overcome, and Aitken is clearly among them. Early works such as *inflection* and *fury eyes* seem to push the linear model – a vehicle traveling at extreme speed, vertically or horizontally – to its limit, and beyond. In later installations, the struggle to dismantle linearity has led to new distributions of time and space, producing intricate labyrinths of folded space/time. The elaborate system of flows and pulses in works such as *diamond sea* (1997), *electric earth* (1999), and *interiors* (2002) cannot be reduced to a linear narrative, let alone to a clear temporal succession. In an interview, Aitken discussed the problems of expressing an alternative, more complex, understanding of time:

FILM AND VIDEO STRUCTURE OUR EXPERIENCE IN A LINEAR WAY SIMPLY BECAUSE THEY'RE MOVING IMAGES ON A STRIP OF EMULSION OR TOPE. THEY CREATE A STORY OUT OF EVERYTHING BECAUSE IT'S INHERENT TO THE MEDIUM AND TO THE STRUCTURE OF MONTAGE. BUT, OF COURSE, WE EXPERIENCE TIME IN A MUCH MORE COMPLEX WAY. THE QUESTION FOR ME IS, HOW CAN I BREAK TROUGH THIS IDEA, WHICH IS REINFORCED CONSTANTLY? HOW CAN I MAKE TIME SOMEHOW COLLAPSE OR EXPAND, SO THAT IT NO LONGER UNFOLDS IN THIS ONE NARROW FORM?[42]

Aitken often returns to the importance of finding new and richer models of narration, and, as a consequence, new ways of approaching temporality. In the most ambitious installations, it is no longer a question of pushing the linear model of time to the verge of collapse, but rather of suggesting more sophisticated and complex networks that allow for temporal heterogeneity in a multiplicity of non-synchronous

42 SAUL ANTON, "A THOUSAND WORDS: DOUG AITKEN," *ARTFORUM*, MAY 2000.

connections, delays, and deferrals. An ambitious work that negotiates all of these issues is the multi-screen installation *diamond sea*, shot during several weeks in the Namibian desert in southwestern Africa. It started with the artist's puzzlement at a huge blank section on a map of the southern "skeleton coast." Trying to gather information about this zone, all the artist could learn was that it is known as Diamond Area 1 and 2, and that it has been sealed off from the rest of the world since 1908. Behind the computer-controlled fences lies a vast territory – more than 70,000 square kilometers – that contains the world's oldest desert, the Namib, as well as an enormous diamond mine. Aitken's camera registers smooth banks of sand, lines of undulation produced by the wind, and sharp shadows contrasting fields of complete darkness with those of the red-hot desert sand. The landscape, with its distinct and almost stylized shapes and lines, displays artificial qualities. At times, it seems to transmute into an image – an image of emptiness, verging on abstraction. Aitken expounds: "Of the five weeks I spent in the 'zone,' the geographic barriers that restricted the space made up the narrative. The landscape itself provided an immeasurable emptiness, a straight horizon line dividing sand, sky, and ocean."[43] In the midst of the vast emptiness, almost entirely devoid of people, a highly sophisticated mining industry is at work around the clock. The intelligent machines seem to function independently of any human involvement. They dig for diamonds, transport sand and rocks, and even survey the territory, protecting their property aggressively. The camera pans fences, metallic scaffolding, an excavator; it zooms in on surveillance cameras and registers a huge black helicopter hovering with the rotor flapping in slow motion. Even if nothing really happens beyond the automated movements, the whole industrial complex exudes an ominous and threatening atmosphere.

43 FRANCESCO BONAMI, "DOUG AITKEN: MAKING WORK WITHOUT BOUNDARIES," *FLASH ART*, MAY–JUNE, 1998, P. 80.

It is the very contrast between nature and technology that becomes the theme of the piece, and Aitken takes pains to present the scenery in slow takes of vastness, interwoven with computerized machines – without making his own moral point of view felt: "The camera became a silent eye focused on capturing light and space from a non-judgmental perspective. Here the focus was on something incredibly elusive. In its installation form, the work cycles without beginning or end."[44] We see the rusty underbelly of a truck and barbed wire; then we see wild horses running freely through the desert, rolling in the sand. We see the mechanical movements of a surveillance camera, and we get a close-up of a horse's eye, blinking in the sun. Even if the contrast between nature and machine represents a clear tension in the work, it's the general mechanization, involving the industrial devices as well as the landscape, which makes the strongest impression, pushing *diamond sea* beyond the traditional nature/culture divide. The cycles of nature – the sun, the waves – are not necessarily in opposition to the artifacts exploiting the natural resources. On a more speculative level, all movements seem to participate in the same iterative process, which is perhaps a cycle of death rather than of life. Nevertheless, the wild horses running through the desert still represent life, and the grasshopper on a wall is alive even if it behaves almost mechanically. The very few humans seem to be reduced to serving the elaborate machinery. It is as if the automated industrial complex is animated yet devoid of life. Everything organic, as Freud claims in *Beyond the Pleasure Principle*, has the inherent drive to return to an earlier and more fundamental state of existence: that of the inorganic. Life is but a detour between an original state of death and a future death to which everything alive is essentially striving. Freud first came across this death drive, Thanatos, when investigating what he called repetition compulsion, i.e., the tendency of certain patients to return obsessively to the most traumatic and hurtful

44 IBID.

experiences. Death, Freud maintains, exists within life as a principle of repetition: a mechanical drive to return to their original state of inorganic matter that precedes all forms of organic life, biological as well as intellectual. The loop, without beginning or end, of *diamond sea* can be read as a grandiose illustration of a return to the mechanical processes of the inorganic produced through mankind's most advanced technologies. Through the implementation of rational calculation in combination with a limitless will to power, life in its most advanced forms turns against itself to produce a metallic environment of death. A bleak and distant moon over the empty desert is the sole witness to this infinitely circular story about diamonds, greed, and sublime machines.

TIME DIFFERENCE

THAT WHICH IS ONLY IDENTICAL WITH ITSELF IS WITHOUT HAPPINESS. [45]

(THEODOR W. ADORNO)

Snow falls from a gray sky while a group of people waits for a bus that never comes. The black-and-white film is so grainy that it's impossible to make out faces or details. On the other side of the street another bus stop stands empty; traffic passes by intermittently. The anonymous crowd lingers; nothing happens. It's March in the small town of Oswiecim, Poland, also known as Auschwitz. British artist Darren Almond's installation *Oswiecim, March 1997* consists of nothing more than two 8mm films projected side by side, showing the two bus stops – one filled with visitors from the concentration-camp museum, the other for those few who wish to travel further into the country. The films have been slowed down considerably, making the hopeless wait more agonizing. Like many of Almond's works, this is a piece about duration, delay, and it affords an intensified experience of time. Where nothing happens, temporality makes itself felt, viscerally. Time hurts.

In *Traction* (1999), temporality is manifest as a bodily phenomenon. Built around an on-camera interview that Almond conducted in an attempt to unearth his father's history as a construction worker, the piece uses the elder's scarred body to establish the chronology. "When was the first time you saw your blood?" is Almond's opening question. Moving from toes and ankles to head and crown, the inquiry reveals an incredible number of injuries, bearing witness to the harsh realities of a working life. "How big was the crack in your head?" Almond queries matter-of-factly. "You were choking on your own blood?" The tripartite installation shows the father giving his report, but the interrogator remains a disembodied voice; the viewer is made privy instead to the reactions of Almond's mother (projected on

45 ADORNO, *EINGRIFFE* (FRANKFURT AM MAIN: SUHRKAMP, 1963), PP. 104F.

a third screen), who, sequestered alone in a room, sobs as she listens to the interview. The images of the artist's parents are separated by an additional projection of an earthmover's mechanical arm overturning brick and rubble. Almond's most explicitly autobiographical work, *Traction* approaches temporality in a brutal way. As a boy, Almond "train spotted" as a way of escaping the small English town of Wigan, where he was born, which introduced him to the world of timetables and clocks. In the summer of 2003, he placed a massive flip clock outside the Giardini in Venice, and perhaps all his works are chronometers in one way or another. Often several layers of temporality make themselves felt: the time measured by mechanical devices; the temporality of the human body; even cosmic time, marked each day by the rising and setting of the sun. In *A Real Time Piece* (1995), a wall-size projection of the artist's London studio was transmitted via satellite to an abandoned shop (which viewers could enter) in another part of town. It's not a dramatic image in any way: you see a table, a chair, a fan, and a digital clock on the wall. No one enters the room; nothing happens – except, every sixty seconds the numbers flip over, causing a surprisingly loud crash. This goes on for twenty-four hours, and in the time it takes the room to get dark and then light again the crash occurs 1,440 times. What we are taking part in, or have become part of, is nothing but a huge clock, broadcast live a couple of miles across the great city.

Although the work is technologically complicated (the artist required assistance from the BBC), it's not the technology so much as a theoretical conundrum that seems to interest Almond. After all, *A Real Time Piece* doesn't present us with anything we don't get in our living rooms every day via live TV. In fact, it offers us much less; but here, the focus on the medium itself, on the live image, makes the basic theoretical predicament conspicuous: spatial distance, temporal presence. We are "here," bodily present in this room, but also "there," in another room, not directly perceivable but nonetheless given.

Understood by Almond as a performance (with time and space as the protagonists), this piece seems to have developed in two directions: one rather traditional, producing a beautiful series of images; the other adding a psychological twist. The first direction led to *Tuesday (1440 Minutes)*, 1997, consisting of photographs that document the changing natural light in the studio each minute for twenty-four hours, resulting in twenty-four tableaux of sixty photographs each. The relation between the rigid grid and the seamless blending of light and darkness results in an elegant piece about cosmic time and the human desire to impose structure on experience. The second direction led to a work relayed live via satellite to the corridors of high culture. *H.M.P. Pentonville* (1997) is a truly innovative piece. Having a close friend in jail, Almond decided to stage a live transmission from a cell at Her Majesty's Prison in North London. Relayed via satellite from the prison, the image of an empty cell appeared live for two hours at the ICA in London. The old and worn space, claustrophobic and depressing, offers no surprise, but the deafening sound from the guards outside – the constant clanging of metal gates and the shrill noise of keys locking and unlocking – is a real shock. The sound builds to a crescendo, and one anticipates, even hopes for, some final eruption of violence. It never comes.

What is it that's so puzzling about real-time projections presented in an art context? To begin with, they're unique; they happen once. Filtered through technologies of mass distribution, they are nonetheless singular, in that they have an open future: we don't know what's going to happen. This is all quite evident, but still worth emphasizing, since it seems to relieve the artwork of the predicament diagnosed in Benjamin's endlessly reproduced essay on mechanical reproduction. There is a videotape version of *H.M.P. Pentonville*, but the original work of art happened only once. (One can imagine any number of simultaneous real-time projections of the same imagery, all spatially distinct. But temporally, it would still be meaningful to specify an

"original" transmission, i.e., a unique event no matter how simple or complex.)

The "other cinema" of artists such as Almond, Ahtila, and Douglas certainly marks a step in the history of the art of moving imagery. In their multi-projection installations, temporal events are "spatialized" so that they can become apprehended within sculptural and architectural rather than strictly cinematic terms. If cinema could produce what Deleuze called crystal-images capturing for an instant the inner workings of time itself, then the temporal possibilities of this "other cinema," exploring more intricate forms of parallelism and synchronicity, are even greater. The simultaneity of several flows of moving imagery grants the possibility not only of dense and temporally multi-layered imagery, but also of intricate constellations and juxtapositions. In short, there are plenty of new tools to question linearity in all its forms. Time, no doubt, is Almond's central theme, chronology his discipline. And I would argue that it plays a key role in the works of all the artists discussed in this essay; in this sense they are all "chronologists." Ahtila once said, "The idea of linearity bothers me, as does the notion of causality that accompanies it and the assumption that a story should become understandable through that formula. I don't think that the mind works like that."[46] So is this the most pertinent issue: to portray the mind in its full complexity?

(A representation of self? With other technical means, artists have pursued similar goals before. One could argue that some of Dan Graham's most important pieces endeavor to represent the structure of subjectivity in all its temporal complexity. In a statement about the temporal specifics of his 1974 installation *Opposing Mirrors and Video Monitors on Time Delay* – which consists of two mirrors, two video cameras, and two video monitors with time delay – Graham

46 MALM, P. 69.

explains what the person entering this arrangement encounters: "A spectator looking in the direction of the mirror, sees [1] a continuous present-time reflection of his surrounding space."[47] That is what we normally expect to get from perception – a trustworthy report of what is there, immediately in front of us and given to the senses. But the installation had further levels, no longer possible to account for with metaphors of perception. The viewer also encounters, "[2] himself as observer." This is the level of self-reflection traditionally described with the mirror as central metaphor. Graham adds one more level: "[3] on the reflected monitor image, five seconds in the past, his area as seen by the mirror of the opposite area." One could claim that the system is equipped with memory, i.e., things don't just disappear once they are no longer perceived. Instead they are given a second run, five seconds later. In 1974, Graham produced a large number of works involving delays and delayed renderings of already delayed imagery. More carefully than any other artist I know of, Graham scrutinizes the functioning of subjectivity, and like a phenomenologist he gives due attention to the temporal modes of mental life. Husserl, as we saw, considered temporality the most basic level of subjectivity: his doctrine of the mind is also a doctrine of time. He distinguished between different kinds of past time – and different kinds of futurity – and meticulously scrutinized the various capacities that allow the subject to relate to them. This "temporal polyphony" is the state we live in continuously, and there are intricate forms of internal delay and synchronicity. Writing about one of Graham's 1974 installations, Thierry de Duve states: "With extremely simple technical means, Dan Graham has fabricated the perfect recorder and the absolute historical 'subject.'")[48]

47 *DAN GRAHAM: WORKS 1965–2000*, ED. MARIANNE BROUWER (DÜSSELDORF: RICHTER VERLAG, 2001), P. 159.

48 THIERRY DE DUVE, "DAN GRAHAM AND THE CRITIQUE OF ARTISTIC AUTONOMY," IN BROUWER, P. 53.

So how is one to understand these recent creations within the history of video art and post-cinematic experimentation? In the 1970s, the first decade of video art, the most common spatial application of the medium was that of the closed circuit. Artists such as Graham, Bruce Nauman, and Joan Jonas all produced works containing feedback loops of live cameras and monitors, installations into which viewers are invited to enter. Drawn into the visual machinery they are not only viewers but instantly also part of that which could be seen, i.e., not only perceiving subjects but also bodies forced into the passive role of the perceived object. In Nauman's claustrophobic corridors and Graham's time delay rooms the viewers run into displaced imagery of themselves on monitors. The moment you enter you are implicated in physically and kinesthetically surprising, even disturbing, ways. In an essay on Pierre Huyghe's *Streamside Day Follies* (2003), an elaborate installation premiered at New York's Dia in Chelsea and symbolically positioned right below Graham's reflective pavilion on the building's rooftop, David Joselit spells out one way of assessing the shift from closed-circuit video to projection. Although many contemporary practitioners of video art emphasize the active role of the viewer as a kind of co-creator or editor of the work, one can still claim that the projection as such represents a step backward when it comes to viewer participation: projection undermines one of the most progressive aspects of the closed-circuit apparatus employed by artists such as Graham: "It's conceptualization of spectatorship as interactive, even if the interaction afforded is the arguably passive one of inserting one's body within a media circuit in order to see it relayed back to oneself, often in distorted form."[49] Compared to commercial cinema, contemporary video projection, of course, establishes an active spectator. It doesn't lull the viewer into the position of a consumer of a ready-made visual politics.

49 DAVID JOSELIT, "INSIDE THE LIGHT CUBE," *ARTFORUM*, MARCH 2004, P. 154.

"No simple line, that seam," says Carol J. Clover in a short essay on Douglas's *Der Sandmann* with its vertical split that runs through the projection.[50] It marks a temporal gap, as we've seen, and creates a kind of syncopation which cuts right through our perceptual field, thus, producing a disturbing sense of disharmony, not to say schizophrenia. This fissure is a kind of wound, says Clover, and relates it to the discussion of the suture of classical cinema. Film studies have for decades theorized the gaps and splits in time and space in cinematic narration and in the spectators' relation to what is taking place on the screen: "The cut that takes us from a man walking in his bedroom to the same man on the morning subway, the series of cuts that facilitate the alternation of shots between two people's faces in conversation, and so on, are deep and wide, and although our narrative and cinematic conditioning and our deep desire for visual coherence and plenitude may allow us to overlook them, we must feel them on some level."[51] Classical Hollywood cinema is constructed in a fashion that makes these cuts invisible. In fact, we hardly ever feel the deep wounds. The works of Douglas and Huyghe bring the wounds to the surface. Here nothing is hidden, and the tools are displayed in such a fashion that nobody can forget that this is all highly artificial stuff, and that there is nothing natural about the ways stories are told on the screen through complex editing techniques intent on effacing the marks of the editing splice. As Peter Gidal points out in *Materialist Film*, editing in the interest of the seamless flow of narrative utilizes rules that demand a considerable amount of self-effacing cuts. They are there, but they are not perceived as cuts. Gidal's credo, echoed by numerous practitioners of structuralist or materialist film, represents a critique of this system of self-effacements: "Where there is an edit, a cut, it must not be hidden."[52]

50 CAROL J. CLOVER, "DER SANDMANN," IN WATSON, THATER, CLOVER, P. 76.

51 IBID., PP. 76F.

52 PETER GIDAL, *MATERIALIST FILM* (LONDON & NEW YORK: ROUTLEDGE, 1989), P. 3.

"After all, cinema is nothing but takes and editing. There is nothing else," says Alain Badiou, who defines cinema as the "seventh art" in a very specific sense: there simply is nothing else that would constitute "the film."[53] Cinema is the impure art, an art that is essentially dependent upon a "general space" in which "the film" relates to the other arts and unfolds its own specificity as a kind of contamination. Thus, "the film" exists only through its relationship to that which it is not, i.e., to the other arts. It does not add itself to the other six pretending to be on the same level as them. Rather, says Badiou, cinema is the "plus one" of the arts and already implies them. "It operates on the other arts, using them as its starting point, in a movement that subtracts them from themselves."[54] Today's post-cinematic experimentation should not be seen as an attempt to invent a new genre, discipline or art form with its own identity. Artists like Ahtila, Douglas, and Aitken are not the inventors of *another cinema* that seeks its own specificity through purification. On the contrary, they make visible what has been there all along: the impurity and heterogeneity of cinema qua cinema. Cinema's force as a contemporary art, says Badiou, lies precisely in turning the impurity of every idea into an idea in its own right. To explore and visualize the parasitism and inconsistency typical of the "plus one" art since its inception is to display cinema's most specific feature – its dependence on and productive interaction with the other arts.

Cinema not only operates on the other arts in a parasitic mode, it also branches out into an extended field. In recent years, we have seen cinema migrate into other objects, as designer Bruce Mau puts it.[55] So many artists today work within a cinematic framework, some

53 ALAIN BADIOU, "THE FALSE MOVEMENTS OF CINEMA," IN *HANDBOOK OF INAESTHETICS*, TRANS.
ALBERTO TOSCANO, (STANFORD: STANFORD UNIVERSITY PRESS, 2005), PP. 78–88.

54 IBID.

55 BRUCE MAU, "CINEMATIC MIGRATION," IN *LIFE STYLE* (LONDON: PHAIDON, 2000), PP. 73–75.

in the analytical way typical of the artists explored in this essay, others with the intention of creating filmic works that convey not only narratives but also an entire cosmology. A case in point is Matthew Barney's *Cremaster cycle*. There are other artists of the same gene- ration who similarly fabricate closed systems of private mythology, but in the world of the moving image Barney appears to be a loner. He is, it seems, a great believer in the *meaning of meaning*. Other artists working close to cinema today, such as Huyghe and Douglas Gordon (who's work certainly requires its own analysis from a chro- nological perspective), are often suspicious of meaning as it is pro- duced through narration; indeed, they could be said to introduce caesuras of non-meaning and blankness into the thick web of sense. Barney's works convey another message. The elaborate biology of sexual differentiation in the fetus, the religious system of the Mormons, the infinitely convoluted esotericism of freemasonry and of the an- cient Irish myths – it's all so blatantly *meaningful*. In fact, Barney is a hyper-productive myth machine, to the point where, it seems to me, most writers have fallen into the hermeneutic trap, losing themselves in the idea of hidden layers of signification. I resist such seductive games of symbolic puzzle-solving, and in this essay I avoid exploring works that invite to such rituals. (This, as the reading of Douglas's *Der Sandmann* hopefully makes clear, does not imply that the works are not intellectually multilayered.)

Today the only works which really count are those that are "not really works at all,"[56] according to Adorno, who saw the notion of the self- identical subject as a historically produced construct bound up with social experiences of reification and objectification. It is obvious, he claims, that "the hardness of the epistemological subject," the iden- tity of self-consciousness, mimics the "unreflected experience of the consistent, identical object."[57] Ahtila's and Aitken's post-cinematic ex-

56 THEODOR W. ADORNO, *PHILOSOPHY OF MODERN MUSIC* (NEW YORK: SEABURY PRESS, 1973), P. 30.

perimentation – intent on capturing a level of subjective experience that precedes objectification – avoids art objects and instead stages experimental environments and perceptual situations (which of course by no means implies that their productions are not materially and technically complex). The subject is not a thing, not an entity, and echoing the German Romantics (and, inadvertently, Husserl, who also insisted that the deepest level of subjectivity eludes all traditional articulation), Adorno insists, "The subject is all the more a subject the less it is so; and the more it imagines itself to *be* and to be an objective entity for itself, the less it is a subject."[58] The ambition to represent a level of experience that is not possible to reduce to any form of object naturally leads to forms of art that try to do without commodities. The subject is not a thing, but rather it is a condition of possibility of things; and an art trying to capture this pre-objective zone is desperately in search of a new medium. Thus, an art arises that tries to avoid objects all together, and the widespread suspicion of the commodity form is given a philosophical foundation more profound than the critique of the workings of the cultural industry associated with the name Adorno.

(Or should Adorno's understanding of the self-identical subject as a historically produced construct be developed further so as to also account for versions of the subject more complex than the reified "hardness" of self-consciousness which, as he puts it, mimics the experience of physical objects? If the notion of subjectivity in question would also encompass a dimension of "non-objective" and "pre-reflective" thought that continuously evades all objectification, then the notion of historical construction would, of course, be much stronger. Such a constructivist idea would also be closer to the approach of this essay, which takes phenomenology as just one ver-

57 ADORNO, "ZU SUBJEKT UND OBJEKT," IN *STICHWORTE* (FRANKFURT AM MAIN: SUHRKAMP, 1969), P. 165.
58 IBID.

sion of an analytic of finitude that establishes temporality at the very origin, or rather *as* the very origin, of finite thought. Perhaps every subjectivation produces its own sphere of lucidity and its own "unthought" through its specific folding of time.)

If the most fundamental dimension of subjectivity is time, every *phenomenology* will end up also being a *chronology*. As the subject returns to itself in search of a sphere of original givenness, it finds the "living present" at the foundation of its own being. This turns out to be not a zone of monolithic self-presence but a heterogeneous origin. According to Husserl, the present is permeated by absence and otherness; only when letting in what is other than itself, can it remain what it truly is. Thus, it cannot be interpreted as a principle of exclusion, closing the ego off from that which is foreign and different. Given the fundamental role of various forms of alterity, the living present must instead be seen as including a principle of hospitality. To use Husserl's metaphor, consciousness is not a bag filled with present contents that are supposed to compensate for things absent.[59] Instead, consciousness is capable of intending what is other than itself; it is capable of transcendence. This is an idea Husserl shares with Bergson. For instance, no image of the past can compensate for the past itself. When we intend a past event through recollection we are not intending some kind of replica or picture. Bergson writes, "The image pure and simple will not take me back to the past, unless, indeed, it was in the past that I sought it."[60] Thus, we are capable of leaping into the past. This leap, or "jump" to another temporal zone is perhaps unexpected in the work of a philosopher considered to be preoccupied primarily with the notion of continuity. The life of the mind is by no means continuous. On

59 HUSSERL, P. 279.

60 HENRI BERGSON, *MATTER AND MEMORY*, TRANS. N. M. PALMER AND W. SCOTT PALMER (NEW YORK: ALLEN & ULLWIN LTD., 1911), P. 135.

the contrary, subjectivity is comparable to a Chinese box. A mazelike configuration of flows given inside each other: perception, empathy, memory, anticipation, and fantasy creating a nested arrangement. We all inhabit many time zones simultaneously. This "hetero-chronology," to use Boris Groys's concept, is the most normal of predicaments. We live in *different times*.

Subjectivity itself is nowhere to be seen. This is fully in accordance with the phenomenological notion of a flow of time-consciousness that appears to itself only indirectly and never in a straightforward fashion. The "flow" which is "absolute subjectivity" can never be grasped through objectifying reflection according to Husserl, because the moment the flow is objectified through reflective acts, it has already vanished. It seems that the deepest level of temporality appears only indirectly through various forms of spatialization. Can a work of art ever visualize such an intricate structure? The format of a traditional feature film can never reflect how perception and memory works, says Ahtila. Obviously her own works endeavor to do so, and works like *Today* certainly hint at a richer structure to accommodate a multiplicity of flows. The "other cinema" of today – that of Ahtila, no doubt, but also that of Tacita Dean – emerges as an attempt to insert spatial models into the temporal dimension, and to "install time" in space. Installing time is a matter of choosing the right spatial model, the most adequate "schematism" allowing the translation of temporal properties into space.

Loops, circularity, and rotation are modes of visualization, modes of (in)stalling time. What they have in common is their ability to make moving images and entire sequences return. Circularity as a cipher of time is an important feature in Dean's projects, perhaps most conspicuously present in *Fernsehturm* (2000), a film shot inside the revolving restaurant of Berlin's famous television tower and one of the GDR's most memorable monuments. Originally, it took one hour

for the restaurant to do a full rotation. After 60 minutes (one look at the full 360° of the city's horizon), one had to leave the highly sought after seat. Today, after the disappearance of Communism, the rotation is twice as fast. You get a view of all of Berlin in just half an hour. Dean likens the revolving restaurant to the spacecraft in Kubrick's *2001: A Space Odyssey*, and describes it as an example of attractive obsolescence. Once it was a symbol of the future; now it is out of date. It's a perfect anachronism that short-circuits our notions of future and past: "As you sit up there at your table, opposite the person whom you're with, and with your back to the turn of the restaurant, you are no longer static in the present but moving with the rotation of the Earth backwards into the future."

Another work connecting rotary motion and time is *Disappearance at Sea* (1996), a film shot at the Berwick lighthouse and displaying nothing but temporality itself and the passage from light to dark when the lighthouse becomes functional. The "event," says the artist, is the "passage of time" itself: "At night, you watch in the blackness for the rotations of the lighthouse and you decipher time in the gaps between the flashes. Without this cipher, there is no time."[61]

61 *TACITA DEAN* (BARCELONA: MACBA, 2000), P. 42.

CUTTING TIME

In the end, John Wojtowicz's story was too good to recount just once. Its first telling came in 1975, via the Sidney Lumet-directed movie *Dog Day Afternoon*, starring Al Pacino as Wojtowicz, the gay bank robber whose heist "should have taken ten minutes," in the immortal words of the Warner Brother's advertisement, but "four hours later, the bank was like a circus sideshow. Eight hours later, it was the hottest thing on TV. Twelve hours later, it was history." ("And it's all true," concluded the ad, breathlessly.) The film depicts Wojtowicz's 1972 attempt to rob a New York City bank to pay for his lover's sex-change operation, and as such could be read as offering a vivid parable of what Guy Debord must have meant by life in the society of the spectacle. Wojtowicz and his accomplice, Sal, were media superstars not for fifteen minutes, but for at least fifteen hours. Indeed, through Pacino and Co., their fame has become eternal (if such a concept is still relevant in the era of spectacle culture). The cosmically botched robbery was covered live on several television stations, interrupting coverage of the Republican National Convention in Miami – indeed, Wojtowicz believes that the threat of further disruptions was what compelled the FBI to get rid of the two bandits as quickly as possible. Sal was killed by the police at JFK International Airport, where the pair were preparing to flee the country. Wojtowicz, whom Life magazine described as "a dark, thin fellow with the broken-faced good looks of an Al Pacino," was given a twenty-year jail sentence.

This was all too much for Pierre Huyghe to resist. An artist known, among many things, for his meta-cinematic experimenting, Huyghe decided to invite Wojtowicz, paroled in 1979, to tell his "real story" in front of a camera. The result is *The Third Memory* (2000), an installation that consists of two projections, each showing reconstructions from different angles of the robbery and hostage-taking in the Brooklyn bank. Wojtowicz, now a rather heavy man in his late fifties, is shown walking around the set built to look like the scene of the

crime, brandishing a rifle, instructing a group of extras where to stand, how to move, and how to act. "OK, this is a stickup," he says. "OK, girls, raise your hands, take a giant step back. Raise your hands slowly. Anyone touch the alarms and I'll blow your brains out." Those who have seen and remember *Dog Day Afternoon* – and if you've seen the movie you do remember it – will automatically make comparisons between the two films, a process that Huyghe facilitates by providing fragments from the Hollywood version in one of the two projections. But how much is Wojtowicz himself influenced by the film? Of course, he thinks he is reconstructing hard facts, but when he refers to what really happened as "the real movie," as he does in *The Third Memory*, one has reason to get suspicious. The situation is complicated: not only were Wojtowicz's looks compared to Pacino's in the press at the time of the robbery, but it was Pacino, along with Marlon Brando, who provided a fictional model for how to be a crook; the robbers had watched *The Godfather* for inspiration the very afternoon of their crime. (In another twist, the same actor who played Fredo in *The Godfather*, John Cazale, played Sal in *Dog Day Afternoon*.) Now the "real" Wojtowicz, who was brought to tears by Pacino's performance when he first saw the film in prison, paces the set, reconstructing the "real" event.

The whole life of those societies in which modern conditions of production prevail presents itself as an immense accumulation of spectacles. All that was once directly lived by John Wojtowicz on August 22, 1972, in a bank in Brooklyn has withdrawn into a representation.[62] This is what the catalogue essay for *The Third Memory* claims. An elaborate paraphrase of Debord's *The Society of the Spectacle*, it develops (in 221 sections) an "aesthetic of reconstitution" that sees all events as "situated" and, therefore, simply impossible to restage.

62 SEE JEAN-CHARLES MASSERA'S ESSAY IN *PIERRE HUYGHE: THIRD MEMORY* (CHICAGO AND PARIS: THE RENAISSANCE SOCIETY AT THE UNIVERSITY OF CHICAGO AND CENTRE GEORGES POMPIDOU, 2000).

Remake, reconstitute, remember: how can one best approach things past? At the very end of the film's nine and a half minutes, Huyghe provides the audience with a third layer of representation, showing a few seconds of television footage from the actual crime scene. We see the young Wojtowicz in a white T-shirt yelling and gesticulating, communicating with the masses in front of the bank. So how should one understand the "reconstitution" of *The Third Memory*? As an attempt to finally get to the truth, to let Wojtowicz take possession of his own face? Or as an additional layer of fiction and role-playing? Huyghe offers no final answers, but he makes these complex problems of time, fictionalization, and memory painfully clear in his double loop.

Like many artists who emerged during the '90s – Gordon, for example – Huyghe has scrutinized the technological as well as the ideological aspects of film as a paradigmatic example of today's spectacle culture. Not all of his pieces deal with the moving image, but during the last ten years he has produced works that relate directly to films by Hitchcock, Pasolini, Bergman, Disney, and Warhol, among others. He has used scripts, sound tracks, and subtitles as points of departure for his various projects, as well as dealing with dubbing, translation, and remaking. Many of these pieces are collaborations with artist friends, Dominique Gonzalez-Foerster and Philippe Parreno among them. Huyghe's meta-filmic obsessions have resulted in a series of large-scale productions that are admirable not only for their artistic rigor but also for their innovative modes of presentation. The effect of his *Sleeptalking (With Sleep by Andy Warhol and the Voice of John Giorno)*, 1998, for example, was due in large part to the spatial component of its installment. On one side of a glass wall, Warhol's *Sleep* (1963), showing the poet John Giorno catching forty winks, was projected in 16mm without audio. On the other side of the glass, one heard Giorno's voice reading a long monologue about the work and about Warhol's technical ineptitude: "And it's true, Andy

did do that and indeed Andy cut real time by the repetitions, blah blah blah, but that was not Andy's intention ... I have this idea that all works of great art are done by mistake." The two rooms were not directly connected. At the Casino Luxembourg, where the piece was first installed, one actually had to walk through large parts of the museum to come to the other side of the glass. This created a strange sense of unreality, and people signaled to one another to make sure that the reverse side was not some kind of visual special effect.

The most typical feature of Huyghe's recent works is the perplexing amalgamation of different levels of reality. The cuts here in question are not only between time zones, but between entirely different ontologies. *The Third Memory* crosses the line between fiction and nonfiction, of course, but so does the triple video projection *L'ellipse* (1998), which takes a cut from Wim Wenders's *The American Friend* as its point of departure. In one scene in the Wenders film, the main character, Jonathan Zimmermann (played by Bruno Ganz), is on the phone in a Paris apartment. Next thing you know, he is receiving horrible news in another apartment on the other side of the Seine. How did he get from one place to the other? We accept such mysterious transports in film; it's the way stories are told. We hardly ever think about these abrupt cuts. *L'ellipse* fills in the gap with reality: we now see Ganz walk across the river, from one apartment to the other (which is quite a distance in real life; it takes a good ten minutes to walk). It's been two decades since he played the role of Jonathan Zimmermann, so, naturally, Ganz looks older. But who is this person in the film – the fictive character Zimmermann? The actor Ganz? Or some character in a new story? Huyghe writes, "A ghost is a character from the in-between, trapped on a bridge between two banks, in a suspended time. *L'ellipse* is a story of a ghost who, in actual reality, comes to haunt a gap that is missing in the narrative ... *L'ellipse* hollows out an imaginary time in the interstices of fiction."[63]

Inquiries into narrative conventions and techniques can be a dry business, but Huyghe's installations are strangely riveting. In recent years, artistic appropriations have reached a point where one may question the real point of one art form (the video installation, say) cannibalizing another (the cinema). No doubt, the multiprojection video installation introduces new forms of narration and viewer participation. Still, why steal from cinema? Perhaps the answer is that video can pose questions to film that film is incapable of putting to itself. This is exactly what Huyghe's *L'ellipse* does, for example, when it makes us aware of the function of the cut and inserts the actual distance and the time it really takes to move from one place in the story to the next.

Another project concentrates on the physical aspects of something even more elusive than a cut in a movie: the voice of a girl in a fairy tale. *Blanche-Neige Lucie* (1997) is a brief documentary about Lucie Dolène, the woman who provided the voice of Snow White in the French version of the Disney film. She explains her situation: "When I gave my voice to that character, that beautiful little princess, graceful and innocent, I was Snow White. … Yes, absolutely. … Today, when I watch the film, I have the strange feeling, it's my voice and yet it doesn't seem to belong to me anymore." Dolène has good cause for concern: Disney was using her voice-over without her permission. After lengthy legal proceedings over royalties, she can again claim the rights to "her" voice. "The happy ending is the fact that, by winning her case, she really becomes Snow White," Huyghe writes. Such a happy ending has not yet been reached in the case of John Wojtowicz, who is still fighting Warner Brothers for the rights to his story as the world-famous bank robber who loved another man so much that he was willing to risk his life to give him the sex-change operation he dreamed of. Wojtowicz is not trying to become someone else,

63 PIERRE HUYGHE, "L'ELLIPSE," IN *PIERRE HUYGHE* (MÜNCHEN AND ZÜRICH: KUNSTVEREIN MÜNCHEN/ KUNSTHALLE ZÜRICH, 2000), P. 145.

be it Snow White or some Hollywood celebrity. All he claims are the rights to himself.

SIMULTANEOUSLY

It's getting late, and Tobias Rehberger decides to call it a day. His
assistants have gone home several hours ago, so he is the last one
to leave. He puts on his jacket, grabs the bicycle and turns off the
light. Now the office is dark and the streetlights and neon outside be-
come more visible. At the exact same time in the exhibition space
of Barcelona's Fundació La Caixa – several hundred kilometers away
– something analogous happens. In a completely black room with
strangely curved corners hangs a lurid lamp made of acrylic. When
Rehberger is at work in Frankfurt's Bahnhofsviertel the lamp in
Barcelona is lit (it's connected to the headquarters via the Internet).
When the artist decides to leave and switches off the light, the black
room in Spain turns absolutely dark. This is what now happens.
Rehberger is already on his bicycle in Frankfurt am Main; the young
woman with black hair at the desk in Barcelona is alone in the space
and she now really feels like going out to see her friends. The quite
beautiful lamp that was shining a second ago is no longer visible.
It's either on or off; there is nothing in-between. This piece, *Treballant /
Trabajando / Arbeitend* (2002), belongs to a group of works that
use light and digital technology to connect a local situation with one
or several other locations around the globe. It started in 1999 with
the piece *Montevideo*, which was presented in a tunnel in a small
Italian town. Linked over the Internet with the city of Montevideo,
it recreated the daylight of this distant place. Perhaps the most ambi-
tious of these projects was the installation *Seven Ends of the World*,
exhibited at the 2003 Venice Biennale and consisting of 111 lamps
ordered in nine groups. As planet Earth circles the sun, different
groups are activated. They shine with increasing strength and then
slowly fade away. The entire room thus functions as a complicated
solar clock that displays the constellation of the two heavenly bodies.
And then there are some rather odd ingredients, like the group of
lamps that bears no relation to the solar trajectory and the natural light
in distant cities like Las Vegas or Kyoto but instead reacts to the clos-
ing and opening of a bathroom door in Mestre just outside Venice.

The work is a poly-rhythmic light machine, at once cosmic and very down-to-earth. The viewer who traverses the room walks from time zone to time zone. And here one sees how the cosmos amounts to what Lefebvre refers to as a "luminous simultaneity."[64]

"The concern with space bores me," wrote Barnett Newman. "I insist on my experiences of sensations of time – not the *sense* of time but the physical *sensation* of time."[65] To a certain extent Rehberger's recent works describe a similar shift, from meditations on space and the design of space to an intense interest in time and the possibilities of designing temporal landscapes. That, at least, is at how I interpret the works that link time zones and make the different temporal flows physically tangible. Tele-robotics and tele-presence are becoming the most ordinary of things, and the very concepts of velocity and location are being renegotiated through our everyday activities. Rehberger's recent light works explore the perceptual possibilities produced by these technologies and their capacity to carry light from one place to another in virtually no time. The key concept explored in these light installations seems to me to be that of *synchronicity*. Things happen *at the same time* in different places. Some of them are very distant, but they are all now.

Let's remind ourselves of Plato's *Timaeus*, where time is called the "moving image of eternity." It consists of days, nights, months, and years: "They are all parts of time, and the past and the future are created species of time, which we unconsciously but wrongly transfer to eternal being, for we say that it 'was,' or 'is,' or 'will be,' but the truth is that 'is' alone is properly attributed to it."[66] That which truly

64 HENRI LEFEBVRE, *THE PRODUCTION OF SPACE*, TRANS. D. NICHOLSON-SMITH (OXFORD: BLACKWELL PUBLISHING, 1991), P. 130.

65 BARNETT NEWMAN, *SELECTED WRITINGS AND INTERVIEWS*, ED. JOHN P. O'NEILL (NEW YORK: KNOPF, 1990), P. 173.

is, is the eternal Present, the Now. To break with this powerful linear conception seems to require a spatialization of a different kind. Rehberger's recent large-scale installations offer such spatial solutions, the journey through which is never predictable and never the same. It's not just the lamps that go on and off – some in a systematic way, others less so. You yourself pass through the installation in an irregular fashion. You move in and out of temporal zones. In works such as Rehberger's 2001 installation in the restaurant of the Dresdner Bank in central Frankfurt, you can have breakfast in Dubai or Moscow, lunch in Tokyo, dinner in Montevideo and a late snack in São Paulo. Or at least you share the light with the people living in these places. Here it is not primarily about getting rid of the linear model of time, but rather of suggesting richer and more intricate architectural models that allow for temporal heterogeneity and multiplicity: there is not one line but (always) many. Such maze-like temporalities – by necessity always thought of in the plural – cannot be visualized as a line of successive points, but rather as a pattern of bifurcating and divergent series, or, in the words of Jorge Luis Borges, as a "Garden of Forking Paths." In his story, Borges alludes to a Chinese architect and philosopher, Ts'ui Pen, who does not believe in a uniform, absolute time: "He believed in an infinite series of times, in a growing, dizzying net of diverging, convergent, and parallel times. This network of times that approached one another, forked, broke off, or were unaware of one another for centuries, embraces all possibilities of time. We do not exist in the majorities of these times. In some you exist, and not I; in others I, and not you; in others, both of us."[67]

Rehberger's most ambitious installations construct such multi-temporal worlds; they harbor not *one* flow of events but a labyrinth of

66 PLATO, *TIMAEUS* 37 E IN *THE COLLECTED DIALOGUES*, EDS. E. HAMILTON AND H. CAIRNS (PRINCETON: PRINCETON UNIVERSITY PRESS, 1961).

67 JORGE LUIS BORGES, *LABYRINTHS*, OP. CIT., P. 53.

diverging paths, *each with its own* pace and temporality. His various projects relate to each other according to a peculiar logic of deferral and return: motifs travel from work to work and create a curious web of thematic connections. A work such as *Seven Ends of the World* represents a maze in itself. As a viewer passing through one of these architectures of glass, light, and time, you decide in which order to perceive the different groups of lamps. This is no longer the well-known line of now-points. Instead, we need to adopt alternative metaphors: the fold, the labyrinth, or the garden of forking paths. Suddenly some of the lamps turn dark. Why is that? Because there's a solar eclipse in Las Vegas or because Rehberger just left his studio and turned off the light? Even more likely, it's just that someone desperately needed to use the bathroom in Mestre.

NOTHING

A THIN VENEER OF IMMEDIATE REALITY IS SPREAD OVER NATURAL AND ARTIFICIAL MATTER, AND WHOEVER WISHES TO REMAIN IN THE NOW, WITH THE NOW, ON THE NOW, SHOULD PLEASE NOT BREAK ITS TENSION FILM.[68] (VLADIMIR NABOKOV)

"How to enchant with practically nothing, a few popular songs, a series of anti-landscapes, some micro-events, lots of emptiness … this low-intensity cinema penetrates our perceptions right to the core of our sensibility," declares writer Nicole Brenez in a brief letter to the editors of *Cahiers du Cinéma* about *Ile de Beauté* (1996), a film co-directed by French artist Dominque Gonzalez-Foerster (with filmmaker Ange Leccia). This, it seems to me, also nicely sums up what Gonzalez-Foerster achieves in her solo filmic experiments, which are sometimes displayed in dark theaters on a screen but just as often branch out to involve architecture, public space, and even whole cities – be it the artist's native Paris or distant metropolises in Asia or Latin America. Indeed, in Gonzalez-Foerster's work, genre no longer seems relevant. Her recent productions include the "cosmic" adventure *Exotourisme* (2002), an "environment" of sound and vision that takes the viewer through an abstract landscape of computer-generated forms; the design of a Balenciaga store in New York; and ambitious lighting and video shows that accompany rock concerts. Asked to describe her open-air project for Documenta 11, Gonzalez-Foerster lists some of the heterogeneous elements that were displayed amid the shadows cast from the large trees south of Kassel's orangerie, and where – on hot days – one could see exhausted viewers dozing away on the lawn: "It's a park; it's a plan for escape; it's an extra-large piece of lava rock that's come from Mexico and landed on the green grass; it's a blue phone booth from Rio de Janeiro; it's a butterfly pavilion screening of a film inspired by *The Invention of Morel*, the fantastic novel by Adolfo Bioy Casares; it's a rose tree from Chandigarh; it is outside, coming from all over the

world." On hearing this catalogue of seemingly unrelated parts – removed from their original contexts but arranged together in subtle tension – one senses that the work is less a particular, circumscribed space or medium than an atmosphere that draws out the melancholy inherent in its pieces.

Still, I ask myself: What exactly is *Park – A Plan for Escape* (2002)? A curious sculpture garden, an installation, or an outdoor cinema equipped with exotic props? Probably it's all of these things, but it's also one more example of what French theorists would recognize as a form of *écriture*. Regardless of technique, Gonzalez-Foerster's work is always close to that active production of emptiness that Roland Barthes – in his book about a fantasized Japan, *Empire of Signs* – counted as writing and which he associated with Zen: "And it is also an emptiness of language which constitutes writing; it is from this emptiness that derive the features with which Zen, in the exemption from all meaning, writes gardens, gestures, houses, flower arrangements, faces, violence."[69] In this sense, Gonzalez-Foerster *writes* gardens, flower arrangements, and, yes, entire cities, often inscribing cinema into the urban landscape – be it a lush German park or the subterranean maze of a Parisian subway station. In *Park – A Plan for Escape*, a butterfly-shaped pavilion is a kind of cinematic machine, a freestanding projection booth presenting imagery of parks from films like Antonioni's *La notte*, Tsai-Ming Liang's *Vive l'amour*, and Resnais's *Last Year at Marienbad*. Bodies and faces appear like ghosts behind the pavilion's glass, hardly discernible during daytime but suddenly entirely visible when night falls. "I like the idea that you can enter the park by chance and encounter these elements in a rather mysterious way without immediately thinking about art," the artist once told me. "It's all not so clearly coded or

69 ROLAND BARTHES, *EMPIRE OF SIGNS*, TRANS. R. HOWARD (NEW YORK: FARRAR, STRAUS AND GIROUX, 1982), P. 4.

framed. You can come across these things any time during night or day and have a very different experience. It's not even clear where it all starts or stops. Beyond this tree, after this cloud …?"

Perhaps it's understandable then, that such a project's origins are somewhat amorphous. One point of departure was a scene from Tsai's film that made such a lasting impression on her that she eventually journeyed to the distant location where it was shot to try to understand it better. A hopeless endeavor, no doubt, but in this case, nevertheless, a productive one. The artist describes it:

IN *VIVE L'AMOUR*, A WOMAN IS WALKING THROUGH A PARK UNDER CONSTRUCTION IN TAIPEI. FIVE YEARS AFTER SEEING THE FILM, I WENT TO TAIPEI MYSELF TO SEE THAT PARK AND TO WALK THAT LANE. IT STARTED TO RAIN. AND THE RAIN BECAME SO STRONG THAT I HAD TO STAY ONE HOUR UNDER A KIND OF SHELTER. A PRISONER IN THE PARK, I FINALLY COULD CONNECT THE FILM AND THE SPACE IN AN INTENSE WAY.

Out of this charged atmospheric moment came her art, and in work after work, Gonzalez-Foerster tries to capture those exquisite sensations that are so evasive they lack names but are distinct enough to be remembered for a lifetime.

(American poet Gerard Manley Hopkins took up a scholastic terminology and described certain specific instances in his poetry as "haeccities." These are occurrences – waves, blocks of sensation – that cannot be integrated into larger narrative structures. These specific moments, writes John Rajchmann, are impersonal in the sense that they precede us as subjects or persons, and yet they are "expressed" in our lives:

AN HOUR OF A DAY, A RIVER, A CLIMATE, A STRANGE MOMENT DURING A CONCERT CAN BE LIKE THIS – NOT ONE OF A KIND, BUT THE INDIVIDUATION OF SOMETHING THAT BELONGS TO NO KIND, BUT WHICH, THOUGH PERFECTLY INDIVIDUATED, RETAINS AN INDEFINITENESS, AS THOUGH POINTING TO SOME-

Bonne-Nouvelle, Station Cinéma (2001), installed at the Bonne-Nouvelle metro station in Paris, was the artist's first major public work and is another attempt to bring filmic associations into an unlikely space for them. Through a number of delicate interventions – a few monitors here and there, various forms of theatrical lighting – she transformed the station's utilitarian underground architecture (stair-cases, passageways, platforms) into a giant cinematic fantasy. Fragments from films shot in the metro appear on the monitors. More conspicuous are the rows of lurid spherical lamps, hovering over weary passengers waiting for the train to finally arrive. For a moment the passengers are transported from the gray and noisy environment of urban transportation to some fanciful theater lobby or perhaps a small-town amusement park. These colorful globes are pure joy.

Escapism? Yes, but not of the sort that suggests a more authentic life, some less artificial or even pre-modern form of dwelling in the world. On the contrary, Gonzalez-Foerster's fantasies often conjure up a kind of tropical modernity connecting abstraction in the arts, visionary architecture, and the suggestion of equatorial fecundity. One example is the fifteen-minute film *Plages* (2001), shot from a hotel room in Rio de Janeiro that overlooks the Copacabana and accom-panied by a patchwork sound track of voices, music, and exploding fireworks. In describing her work, one falls into Gonzalez-Foerster's own elliptical manner of recitation; such is the power of the mood she creates. We see the beach at night, with people dressed in white on the sand. The camera moves away from the water, and we see the street lined with palm trees and full of cars. On the sidewalk there is a black-and-white wave pattern. A voice belonging to Diogenes

71 SEE JOHN RAJCHMAN, *THE DELEUZE CONNECTION* (CAMBRIDGE/LONDON: MIT PRESS, 2001), P. 85.

Paixao, a Brazilian art collector, explains: "It's the biggest drawing in the world. The landscaped gardens of Copacabana. He was very proud of it, you know. Always saying: 'It's the biggest drawing!'" He is talking about Brazilian artist and garden architect Roberto Burle Marx, and soon the camera zooms in on the abstract wave design. The people moving back and forth along the strand seem to follow the pattern. What we experience is the crowd – always the group rather than the individual person. This is a film about a collective state of mind called the Copacabana. The sun has set and it's getting dark, but the beach is lit by spotlights and small fires in the sand. A collage of voices, talking and singing, delivers a dense and poetic account of life at the waterfront: "Copacabana has no center. No ties to the golden youth … A sort of oasis." Explosions from the fireworks get more and more volcanic, turning the screen into Turner-like cascades of color – fire and smoke that produce imagery verging on abstraction. Then it starts to rain, and the crowd hides under umbrellas. "If there is one place where mankind's utopia exists … Copacabana must be that place," says one voice. The crowd continues to move along the wave pattern, and we hear a last statement, delivered by a local fisherman: "Copacabana is wonderful. It's a wonderful city. Copacabana doesn't exist."

Plages is the last film in a kind of trilogy that also includes *Riyo* (1999), shot in Kyoto, and *Central* (2001), featuring a woman in black waiting for her brother to arrive at the Star Ferry Terminal in Hong Kong. (In addition to her own films, Gonzalez-Foerster has collaborated on others: in 2001, she co-directed two films, the aforementioned *Ile de Beauté* and *Gold* [2001] with video artist Ange Leccia; in 2000, she added an episode to the story of AnnLee, a series of artworks about a Japanese manga character initiated by Huyghe and Parreno; and the following year she teamed up with Swedish musician Jay Jay Johanson to produce *Cosmodrome*, an experiment with sound and light using pre-cinema technologies and reminiscent of the nine-

teenth-century panorama.) All three films – *Plages, Riyo*, and *Central* – focus on moments of urban experience and, in particular, on an intensified sense of the flow of time. In *Riyo* the flow is both literal and impressionistic: the camera travels smoothly along a riverbank in Kyoto where young couples meet in the twilight of the early evening. Neon lights, luminous facades, and an occasional exploding firework illuminate the scene. A cell phone rings and we hear a young woman's voice: "Hello!" A man's voice replies: "Hello..." She continues: "Don't you remember? We met in Shirahama... My name is Riyo..." A telephone discussion (in Japanese with English subtitles) about recent memories, amorous hopes and geographical distance ensues, accompanied only by the image of shining neon lights and the streaming water in the river. Flirtation in Japanese – it's different sounding yet familiar. Nothing much happens, time is passing. Somehow the lack of imagery, the monotony of the water, and the slow movement of the camera produce a space in which time itself seems to imbue the urban landscape.

In *Central*, this sense of time flowing (but getting us nowhere) is even more intense. It's early morning at the ferry terminal. A woman dressed entirely in black, appearing as a silhouette, is looking out across the water, waiting for something. "This girl is black," says a voice off camera. "She looks like the monolith from *2001: A Space Odyssey*." A long monologue then follows about the expected encounter and about time. People show up in the bright morning light. They look out across the water, do their morning rituals – a few gymnastic steps, some moments of silent meditation. Each and everyone for himself: "Now is a moment without limits. Everything begins anew. Everyone carries his own space around. Does his own little dance. It's the present." There is the attraction of the foreign city, but there is nothing especially exciting or exotic about the scene. In short, there is nothing surprising. The tone of precise indifference in Gonzalez-Foerster's films have been described as a reaction to the

spectacle machine of global culture: we can travel the world without ever finding anything surprising, and if there is such a thing, we get suspicious since now everything surprising seems to belong to the market and to the realm of the spectacular. We may as well rest our eyes and try to tone down our curiosity. Nothing new in Kyoto … "So what? Nightfall instead of exoticism, light conversation instead of sham depth."[72]

In many of her installations, this blankness is expressed quite physically, as she leaves large spaces empty. Such was the case a few years ago in *Brasilia Hall* (2000) where a green carpet covered the floor of a vast area at Stockholm's Moderna Museet, otherwise displaying nothing but an orange neon sign spelling out the title and a small monitor built into the wall showing imagery from Oscar Niemeyer's Brasilia – certainly a prime example of that "tropical modernity" Gonzalez-Foerster tends to return to. But the spatial void at the center of these works seems to me only one more way of indicating what most of them express on a level of signification or, more precisely, through their strategic *lack* of signification. "Writing is after all, in its way, a satori," claims Barthes, "a more or less powerful seism which causes knowledge, or the subject, to vacillate: it creates an emptiness in language."[73] This enchanting emptiness is the productive force in Gonzalez-Foerster's works. She has captured and recorded lacunae of meaning in places as distant as Brazil, China, and Japan, but they are also to be found at the very core of our everyday experience. Now that she's shown me, I find the liberating emptiness everywhere. The construction of the urban atmosphere, even of the city itself, takes place "inside the viewer," says Gonzalez-Foerster. The seism that causes knowledge to "vacillate"

72 MASSERA, IN *DOMINIQUE GONZALEZ-FOERSTER. FILMS* (DIJON AND FRANKFURT: LE CONSORTIUM/PORTIKUS, 2003).

73 BARTHES, P. 4.

is a kind of writing, thus a form of exteriority, which makes possible it's own specific forms of atmospheric subjectivation. A transitional and floating choreography ("drift, playtime") give rise to an ephemeral occurrence, what the artist calls a *moment*. This, for instance, is a highly specific moment that represents a particular subjective mode:

ON SUNDAY AFTERNOONS 'GINZA' – TOKYO'S FAMOUS DISTRICT – IS GIVEN OVER TO THE PEDESTRI-ANS AND CLOSED TO AUTOMOBILES. AS A RESULT, THE ATMOSPHERE CONSTANTLY CHANGES, THE ASPHALT IS CROSSED IN EVERY DIRECTION, A MUSIC-LIKE FEELING SLOWLY MOVES IN, DAILY EVENTS TAKE ON A COLORFUL ASPECT, AND A SUBTLE AND TRANSGRESSIVE CHOREOGRAPHY IS SET.[74]

74 DOMINIQUE GONZALEZ-FOERSTER, *MOMENT GINZA* (GRENOBLE AND STOCKHOLM: MAGASIN/ FÄRGFABRIKEN, 1997), P. 79.

FUTURE ARRIVALS

If the future existed in a concrete sense as something that could be discerned by "a better brain," we wouldn't be so seduced by the past. But the future, says Nabokov, has no such reality. It is but "a specter of thought." Probably Philippe Parreno sees things in a similar way, and yet this specter of thought – futurity – haunts much of his work and sometimes gains an unusual solidity. A window opens up, and the future is there, strangely visible before our eyes. This, it seems to me, is what happens in *El Sueño de Una Cosa* (2001). "The Dream of a Thing," says Parreno, "is a game that produces new stories each time it is played; these are the stories of a film in a permanent pre-production stage." It's been aired in the movie theaters of Sweden, inserted in the middle of the advertisement program. Its second showing took place in an art context. Parreno describes it: "A painting of Robert Rauschenberg, *The White Series Painting*, is visible during 4'33", the time for the painting given by John Cage. At the end of this score of silence, as in a haunted museum of a theme park, the light fades and the film is projected on the painting."[75] What we obtain in the darkness is nothing less than a glimpse of the future, a moment of visibility not yet integrated into a narrative and, thus, unburdened by history, experience, and meaning: sixty seconds of a future form of life and, it seems to me, a different sense of chronology, evolution, and causality.

"The search for personal liberty is becoming more and more synonymous with a quest for the non-narrative," says Parreno, and adds, "the time ought to be taken to develop this. But in the eventuality of a total absence of narrative, fantastic stories are always there to fill the void."[76] In *El Sueño de Una Cosa*, the fantastic "story" is one of anomalous growth and strangely synthetic vegetation. Surely the

75 PHILIPPE PARRENO, *ALIEN SEASONS* (PARIS: ARC/MUSÉE D'ART MODERNE DE LA VILLE DE PARIS, 2002).

76 PARRENO CITED IN STÉPHANIE MOISDON, "WHITE NOVA," IN *TURBULENZ*, ED. JOCHEN VOLZ, (FRANKFURT AM MAIN: PORTIKUS, 2004), P. 19.

scene is not taking place here and now; it's all in some other place and in some radically different time, yet it seems undeniably and overwhelmingly present. The beginning of Edgar Varese's 1954 "Deserts," often described as a music of expectation, amplifies the anticipatory quality and the sense of arrival. An arrival of what? The scenery of the film is also the territory of expectation, a transparent desert where the vegetation seems to develop according to its own peculiar chronology. The images, taken in the "paleness of a midnight sun," have been filmed in 35mm to keep the "quality of immanence, of presence."[77] The film has been compared to a Nasa pilot displaying future events planned in outer space: a kind of rehearsal taking place not in real time but in some tense as yet unheard of. "When it turns to science fiction, cinema closes its eyes and moves into a rich and uneasy sleep,"[78] writes J. G. Ballard. That is not what happens in Parreno's film. This is not science and not fiction, and we are all wholly awake and attentive. Our brains, it would seem, have been liberated from the Euclidean coordinates, and can now process images and sounds of a radically different order. Perhaps this art of the future no longer can be understood in terms of an organic brain but instead forces us to invoke a device at once mechanic and sentimental: "The programming for Parreno does not have to do with the brain, but with the machine (human and sentimental), with an art of the future at loggerheads with science as well as with fiction."[79] Parreno has little in common with those artists – Douglas and Dean would be prime examples – who find inspiration in obsolete technologies and outmoded means of communication. His is an art of anticipation and emergence. If Ahtila travels through the labyrinth of pastness and explores the mind as a memory machine, Parreno invests only in the future and shows no interest whatsoever in the

77 IBID., P. 17.

78 BALLARD, P. 17.

79 MOISDON, P. 17.

past. Consequently, his notion of subjectivity, if that is still the relevant term, is radically different. In fact, it seems to me that Parreno's work represents a great challenge exactly because of the total lack of a retrospective mode. Like no other artist, Parreno forces us to rethink the notions of emergence and arrival. All notions of subjective "depth" and perceptual "thickness" – dependent as they are on established concepts of interiority as capsules of pastness – are inadequate. A theory of a subject that constructs itself in relationship to the future rather than through modes of *Erinnerung* (remembrance) seems to require an entirely novel architecture of time. Imagine Varela's representation of the non-linear network of retentions (see above), but invert it so as to emphasize the subject's anticipatory drive and openness to a variety of futures, i.e., highlight the plurality of protentions rather than the retained past, and you will perhaps move towards a topological rendering of a subject compatible with Parreno's subject of the future.

(Architectures of the future: Parreno's and architect François Roche's collaborative "Battery House," a hall for large gatherings and a kind of biotechnology-driven hyper-plug that will solve the electricity problem at the Thai artist commune The Land, certainly testifies to a futurist predisposition. Built as an unusual film set for Parreno's *The Boy from Mars* (2003), the eccentric-looking building is powered by animals (local elephants or buffalos) and seems to me to represent a break with the traditional organism/artifact distinction. This is a building that "breathes and perspires, something between Clement Adler's early bat-winged airplane and a Spielberg pterodactyl," according to Roche. In a short essay, "Hybrid Muscle," he spells out the functioning of the battery house and its intimate cooperation with humans and animals: "In front of them is a structure made of still-inert plastic leaves holding a 20-tonne concrete counterweight, hanging vertically like clothes in a European miners' locker room. Their job: to lift them patiently, one by one, using a system of cables and pulleys, moving

with animal slowness. Thus, muscular energy (2,000 w/h) is trans-
ferred, stored, and released, and thereby transformed, by means of
a dynamo, into electrical energy. This endless cycle from elephant
to structure to gravity and then to energy compresses or frees interior
space, in rhythm with the occupation of The Land and the movement
of the counterweight platform.")[80]

In the future perhaps there will be no past. There is a proximity in at-
titude between Parreno and Aitken, who seems similarly uninterested
in ruminations of the past and in the mnemonic depth of the human
mind. Humans are almost entirely absent from Aitken's *diamond sea*
but the passage of a body through fully automated surroundings is
the theme of another somewhat related work, the impressive eight-
screen installation *electric earth*, which starts with what was absent
in Aitken's earlier work: the gaze of a human eye. The protagonist,
played by Ali Johnson, lies prostrate on a bed, a remote control in
hand, gazing at a TV airing nothing but static. The eyes, the remote
control and the monitor seem to define his confined universe. His
drowsy stare expresses nothing but boredom and low energy; it is
as dead as the flickering monitor. He mutters, "A lot of times I dance
so fast that I become what's around me. It's like food for me. I, like,
absorb that energy, absorb the information. It's like I eat it. That's
the only now I get." Is he an inmate in an electronically controlled
cell, or a guest in some desolate motel room? It would appear the
latter, because the next thing we know, he is off on a night-time
stroll, repeating over and over again the last phrase like a secret
mantra, "That's the only now I get, that's the only now I get." Gone
is the fatigue of the motel room; now begins his high energy trek
across electric earth, an urban environment as devoid of humans as

80 CITED IN *PARRENO*. SEE *I'VE HEARD ABOUT ... (A FLAT, FAT, GROWING URBAN EXPERIMENT)* (PARIS:
ONESTAR PRESS AND ARC/MUSÉE D'ART MODERNE DE LA VILLE DE PARIS, 2005), FOR A RICHER ACCOUNT
ON ROCHE'S ARCHITECTURAL SPECULATION.

the automated desert in *diamond sea*. He is alone. He passes the airport at sunrise, his hands mimicking the rotation of the huge satellite dish. Night suddenly returns, as if time decided to rewind just before daybreak, and he walks the deserted streets of an empty shopping area, passing a closed supermarket and a trophy shop. His walk, increasingly mechanical and spasmodic, develops into a bizarre dance that seems to conform to its surroundings in a continuous attempt to copy the syncopated rhythms and movements of the automated environment. "A lot of times I dance so fast that I become what's around me." He keeps to his initial declaration; this is a night of magical automatons.

Or is it the other way around? Maybe it is the electric paroxysms of this dancing wizard that animate the inorganic surroundings. At times, it seems that it is his dance that sets the objects in motion. Car windows roll up and down mysteriously; a car wash comes alive; a shopping trolley in a deserted parking lot suddenly fills with spasmodic energy. He stands in front of a Coke machine trying to insert his dollar bill, but the machine spits it out again, then pulls it back, producing an epileptic fit that seems to spread from the machine to his body. There is no longer a sharp dividing line between organic body and machine. The automatic movements of a surveillance camera mimic the nocturnal wanderer – or is it vice versa? All the mechanical noises produce rhythms for dancing. The spasms in front of the Coke machine escalate into an ecstatic dance, the lonesome dancer breathing more and more heavily as the music turns into abstract drum and bass accompanied by the pulse of city lights. Aitken says, "The landscape in *electric earth* is stark and automated, but the electricity driving the machines is ultimately more important than the devices it drives. It's what the protagonist responds to, and, in turn, what puts him in motion."[81] This electricity, which seems to

81 SAUL ANTON, "A THOUSAND WORDS: DOUG AITKEN," *ARTFORUM*, MAY 2000.

pass through the environment as well as through the protagonist's body, does not distinguish between organic and inorganic, between natural and artificial.

This vision clearly represents a break with the traditional organism/artifact distinction, and seems closer to the view that everything is machine-like, a notion that can be found in the cosmology of G. W. Leibniz. In his *Monadology* (1714), he states: "Every organic body of a living being is a kind of divine machine or natural automaton, which infinitely surpasses any artificial automaton, because a manmade machine is not a machine in every one of its parts … . But nature's machines, living bodies, that is – are machines even in their smallest parts, right down to infinity."[82] Thus, there is no difference of kind between a living body and a mechanical device. In Leibniz's Baroque cosmos, organic substances are no different from inorganic ones. "Whether organic or inorganic, matter is all one,"[83] says Deleuze. In *electric earth*, the automatic paroxysm of the inorganic environment seems to communicate intimately with the paroxysms of the protagonist's bodily parts. Yet there is a major difference between their visions: the Baroque philosopher's universe is one of stability and harmonious co-operation between all parts; Aitken's apocalyptic Baroque is one of dysfunctional friction and collapse. The systems of communication are no longer operative. Things don't work; they only display the mechanical spasms and automatic convulsions typical of devices on the verge of total breakdown. And yet, perhaps there is something new emerging. An emergent form of life?

82 G.W. LEIBNIZ, *PHILOSOPHICAL TEXTS*, ED. AND TRANS. BY R.S. WOOLHOUSE AND RICHARD FRANCKS (OXFORD: OXFORD UNIVERSITY PRESS, 1998), P. 277.

83 GILLES DELEUZE, *THE FOLD: LEIBNIZ AND THE BAROQUE* (MINNEAPOLIS: UNIVERSITY OF MINNESOTA PRESS, 1992), P. 7.

So what is the hyperkinetic stroll in *electric earth* really about? Aitken expounds,

IT'S STRUCTURED AROUND A SINGLE INDIVIDUAL, WHOM I IMAGINED AS BEING THE LAST PERSON ON EARTH. HE IS IN A STATE SOMEWHERE BETWEEN CONSCIOUSNESS AND UNCONSCIOUSNESS, AND HE IS TRAVELLING THROUGH A SEEMINGLY BANAL URBAN ENVIRONMENT IN THE MOMENTS BEFORE NIGHTFALL. AS HE MOVES, THE WORLD AROUND HIM – A SATELLITE DISH, A TRASH BAG SPINNING IN THE AIR, A BLINDING STREETLIGHT, A CAR WINDOW – BEGINS TO ACCELERATE.[84]

Is this a gloomy vision of the future, showing the last human in a world populated only by machines, the last man himself on the verge of final mechanization? Such an interpretation would be in line with the understanding of *diamond sea* as a grandiose scenario showing the *danse macabre* of death machines, but Aitken's narratives can never be pinned down in such an unambiguous fashion. They are open-ended and circular. What does seem clear, though, is that the predicament displayed in *electric earth* is that of a human body that can no longer be described in the terms of traditional humanism or phenomenology: the human as a reflecting being in control of its own actions and thoughts and enjoying a harmonious relation to its own body. The rhythmically advanced cybernetic machine in *electric earth* is an amazing performer, but the dance is not one of serene self-awareness; it is, rather, one of technological disturbance and crisis. The phenomenological subject has always been described as existing in the immediacy of the Now. Yet Aitken's protagonist has clearly lost this sense of presence; instead he is in a state of continuous flux with a different experience of time: "That's the only now I get."

With regard to this nocturnal high-tech stroll, the artist has described the experience in temporal terms:

84 "A THOUSAND WORDS," *ARTFORUM*, MAY 2000.

TAKING A WALK CAN BE AN UNCANNY EXPERIENCE. PROPELLED BY OUR LEGS, WE FIND RHYTHMS AND TEMPOS. OUR BODIES MOVE IN CYCLES THAT ARE REPETITIOUS AND MACHINE-LIKE. WE LOSE TRACK OF OUR THOUGHTS. TIME CAN SLIP AWAY FROM US; IT CAN STRETCH OUT OR BECOME CONDENSED. BUT THIS LOSS OF SELFPRESENCE, IT SEEMS, CAN SOMETIMES PRODUCE ANOTHER KIND OF TIME: THE SPEED OF OUR ENVIRONMENT BECOMES OUT OF SYNC WITH OUR PERCEPTION OF IT. WHEN THIS HAPPENS, IT CREATES A KIND OF GREY ZONE, A STATE OF TEMPORAL FLUX. THE PROTAGONIST IN ELECTRIC EARTH IS IN THE STATE OF PERPETUAL TRANSFORMATION. THE PARADOX IS THAT IT ALSO CREATES A PERPETUAL PRESENT THAT CONSUMES HIM.[85]

This perpetual present, "the only *now* he gets," is not a simple temporal atom but rather the effect of complex systems of communication and of technological detours. The subject – if that term can still be applied – is no longer characterized by unity and oneness. Instead it appears as part of a network of flows and pulses, openended and unpredictable. Its sense of a *now* arises when the present merges with its technological surrounding and becomes part of the all-encompassing place known as "electric earth." From the phenomenological perspective, the lived body represents the absolute "here and now" of experience, the firm ground around which everything else revolves. The situation that Aitken describes in *electric earth* clearly puts this into question; it would seem that the construction of subjectivity through new technologies and the media cuts right to the very bodily core of human identity.

The landscape – whether it be Namibia, Guyana or the suburbs of Los Angeles – plays a central role in most of the works, but it's never a question of a pure natural landscape, untainted by culture and technology. On the contrary, today's artificially altered sense of nature has rarely been captured with such precision as in Aitken's videos, not only when the landscape has given way to the mediascape of Los Angeles, but in those works where the cultural traces

85 IBID.

are more delicate. Shot in Jonestown, Guyana, where in 1978 the followers of Reverend Jim Jones committed mass suicide, *monsoon* (1995) is a film showing fragments of a village that has been repossessed by the jungle; birds and crickets provide the soundtrack. The camera zooms in delicately on small details – a red flower, parts of an old tractor, ants scurrying along a crack in the dry earth – and seems to make no distinction between nature and artifact. Then we get the larger view: dark clouds, a storm arriving. The footage offers nothing but the anticipation of a monsoon. This was the artist's only preconception of the piece: he would go to the site of the tragedy without a shooting script and stay until a monsoon arrived. One hopes for a storm that can wash away all the remnants of the past, finally deleting all traces of the sad sect.

The strain increases every second, but the rain never comes. Momentary images of still beauty – a green bush against the clear sky, the patterns of leaves against the blue – give us solace, but the tension builds. As viewers, we are caught in the unnerving interval between the memory of pain and a future that never arrives. "I was interested in inaction, or waiting," says Aitken. "Waiting in this location for as long as it takes for a monsoon to hit. In the end, the emphasis became more on the subtleties that we found: this is what ultimately created the narrative."[86] When the rain seems to be coming close, the work suddenly comes to an end.

The understanding of landscape as a complex conglomerate of disparate elements was clearly formulated in Robert Smithson's projects. In "Proposal" (1972), he contended:

THE VISUAL VALUES OF THE LANDSCAPE HAVE BEEN TRADITIONALLY THE DOMAIN OF THOSE CON-
CERNED WITH THE ARTS. YET ART, ECOLOGY, AND INDUSTRY AS THEY EXIST TODAY ARE FOR THE

86 FRANCESCO BONAMI, "DOUG AITKEN: MAKING WORK WITHOUT BOUNDARIES," P. 80.

MOST PART ABSTRACTED FROM THE PHYSICAL REALITIES OF SPECIFIC LANDSCAPES OR SITES. HOW WE VIEW THE WORLD HAS IN THE PAST BEEN CONDITIONED BY PAINTING AND WRITING. TODAY, MOVIES, PHOTOGRAPHY, AND TELEVISION CONDITION OUR PERCEPTIONS AND SOCIAL BEHAVIOR.[87]

The list of relevant visual technologies has since been added to, yet in many ways one can see Aitken's interest in the contemporary landscape as a continuation of Smithson's meditation upon nature, art, and abstraction. Aitken's automated milieus and the abstract, sometimes monochromatic, qualities he finds in the landscape are also reminiscent of Smithson's observation in "Nature and Abstraction": "There is no escaping nature through abstract representation; abstraction brings one closer to physical structures within nature itself."[88]

If a history of the American sublime is to be traced via artists such as Newman, Smithson, and Turrell all the way up to Aitken's video installations, then one must keep in mind the altered sense of the experiencing subject. The sublime experience in the Romantic tradition was defined in Kantian terms as an experience of the subject's inner capacities to comprehend infinity. The vastness of a landscape, as depicted by, say, Caspar David Friedrich, was seen as a manifestation of the subject's inner struggles. The modern American subject of Newman's writings is equally heroic: the sublime American image mirrors modern man: "Instead of making cathedrals out of Christ, man or 'life,' we are making them out of ourselves, out of our own feelings." In more recent artists such as Smithson and Turrell, the heroic subjectivity of Romanticism and Abstract Expressionism is no longer in place, but their artistic projects can nonetheless still be understood in terms of a phenomenology: in Turrell's case a pheno-

87 ROBERT SMITHSON, *THE WRITINGS OF ROBERT SMITHSON*, ED. NANCY HOLT (NEW YORK: NEW YORK UNIVERSITY PRESS, 1979), P. 221.

88 IBID., P. 219.

menology of perception linking the eyes to kinesthetic experience; in Smithson's case a more extreme archaeology of cultural sedimentation.

Aitken's world, it seems to me, can no longer be understood in terms of a traditional phenomenology; his landscapes are not directed towards a subject. This becomes increasingly clear in installations where a multiplicity of perspectives co-exist and where the "brain," in Deleuze's words, "has lost its Euclidean coordinates, and now emits other signs."[89] These "other signs" can no longer be linked to the unifying concept of a subject. In works such as *electric earth* (1999), *I am in you* (2000), or *Interiors* (2002), the self is a zone where time and space intersect in a variety of ways, and the very concept of experience must be thought of in terms of this plurality. *Interiors* is an installation that features a series of seemingly disparate narratives. The characters move through vivid environments, including a Tokyo penthouse, an urban junkyard, and a Los Angeles helicopter factory. The various paths never come together in a synthetic whole.

Eraser (1998) records the artist's trek across the Caribbean island of Montserrat a year after it was devastated by the eruption of a volcano. The artist followed a perfectly linear, seven-mile path from the north to the south, from coast to coast, recording the post-catastrophic landscape. The camera sees abandoned houses, a clock tower, an empty street, the interior of a chapel, a red telephone covered with sand. It zooms in on single objects and details: remains of the life that once flourished on the island. This journey through a wild and even hostile landscape is intensely melancholic. Dry, cracked earth; a wild forest; old industrial machinery: this is a journey through an unknown world. Despite all the things encountered, absence is what is most strongly felt. The sound – a composition of

89 GILLES DELEUZE, *CINEMA 2: THE TIME-IMAGE*, P. 278.

fragments recorded on site, looped and stretched – intensifies the melancholic mood. The voice of Louis Armstrong coming from a radio playing for nobody fades away into the night.

The camerawork produces a sense of proximity and immersion. As if the viewer is winding a path through the jungle and searching out the shelter of a vacant building, *eraser* attempts to erase the distance between the viewer and the landscape, to involve the viewer to such an extent that the work becomes part of their stream of experience and vice versa. Putting such emphasis on the viewer could be seen as the ultimate phenomenology, and one could perhaps claim that the complete immersion in *eraser* pushes the viewer's subjectivity to a point where the phenomenological model of experience breaks down. This more complex space allows for the participation of the viewer but also brings the viewer's unity and stability into question. In works such as *electric earth*, the complexity not only has to do with the multiple projections, but also with the active involvement of viewers who decide their own pace when moving through the installations. Such kinesthetic and perceptual multiplicity can no longer be thought of in terms of one harmonious experiencing subject. If the sublime landscape of the Romantic painter was understood as a manifestation of the subject's inner struggles, the protagonist in *electric earth* not only moves through the environment but seems to become part of the electrified landscape. He is a multiple projection of the environment, rather than the other way around.

The routes through space that these video works trace are never linear, but hint at elaborate narratives: circular, multi-layered, and open-ended. The sense of time out of which the stories are constructed can hardly be understood in terms of a linear succession; other spatial models are needed. Not the space of science, but an experimental space that makes this new flow of events perceptible. In trying to visualize and communicate an alternative conception of time,

we are forced to adopt alternative spatial metaphors such as the Borgesian garden of forking paths.

That which truly is, is the eternal Present, the Now. Such is the Platonic teaching, inherited by an entire tradition leading all the way up to modern attempts – such as that of phenomenology – to come to grips with the flow of time. The comet – to return once again to Husserl's image – traces a luminous line. The line represents the succession of now-points, but the *now* itself is constantly new. The comet must be conceived of as constantly reborn, new in every moment. To break with this powerful linear conception seems to require a spatialization of a different kind. Aitken's large-scale installations offer such spatial solutions, the journey through which is never predictable and never the same. Ali Johnson's body in *electric earth* emerges as the product of a technological environment run amok. And the viewer who moves from one segment to the next in this complex cinematic corridor becomes part of the scenario, not only through empathy, but through the physical experience of the work. It's his/her bodily conduct and kinesthetic experience that determines the rhythms and structure of the work. *electric earth* takes place in and through the viewer's body, itself always a plurality.

The self is never a given in Aitken's works. The subject, or, rather, new forms of subjectivity emerge via complex systems of detour and technological mediation. The mind has no direct line to itself, but must pass through various complicated systems of mediation. Such seems to be the predicament described in Aitken's automated cosmos, where the displacement of the subject in time is a natural consequence of the digitized topography it inhabits. The human eye is equipped with all kinds of machines that widen its reach. But it cannot see itself see – at least not without the help of mirrors or a prosthetic sub-system. Visual technologies abound in Aitken's universe: the film camera; surveillance equipment; radar dishes; the

remote control; flickering monitors. To the computer file, sound and vision represent nothing but data to be translated and manipulated freely. Through advanced robotics, the kinesthetic sensations of the body can be broken down to basic signals. Thus, the living body as a last point of reference disappears and a world of freely circulating information is born. One of Aitken's installations, *I am in you*, gives us a glimpse of such a universe. The last agonizing bodily paroxysms that we experienced in *electric earth* are gone. This is a harmonious world of child's play, piano music, and divine geometry. A young girl whispers, "I like to run and not slow down. I like to see and look." We see her eyes, over and over again, sometimes in extreme close up. A blue monitor grows and soon covers the whole field of vision, thus producing one of those monochromatic moments typical of Aitken's work. We see bodies falling through space, and airplanes sucked into some vortex-like vanishing point at incredible speed. Even if the passage through this five-projection installation is more harmonious than Ali Johnson's nocturnal urban trek, it is by no means without its intense and dramatic moments. All sense of traditional architectural space is gone; we move through a strangely unanchored space where everything floats freely, producing a hallucinatory sense of eternal recurrence. Things attempting to escape this cosmos are sucked back by a mysterious force. Even time is absorbed this way. A candle burns producing a deafening sound; a car rides along the street with no one at the wheel. The girl's voice whispers over and over again, "You can't stop." Who drives this universe, who inverts its course of events? Who am "I" and who are "You" in *I am in you*?

Most of Aitken's works have explored a specific site with particular histories and memories; *electric earth* depicted a rather generic urban landscape, but in *I am in you* all sense of geography and locality has evaporated into a cycle of dream-like imagery. If "I" am not here, living in this body, feeling with these hands and seeing with these

eyes, then I am everywhere or nowhere. Virilio sums up our predicament in a series of questions:

FOR IF MAN'S SPHERE OF ACTIVITY IS NO LONGER LIMITED BY EXTENSION OR DURATION OR EVEN OPAQUENESS OF OBSTACLES BARRING HIS WAY, WHERE IS HIS PRESENCE, HIS REAL PRESENCE, LOCATED? 'TELE-PRESENCE,' NO DOUBT, BUT WHERE? FROM WHAT STARTING POINT OR POSITION? LIVING-PRESENT, HERE AND THERE AT THE SAME TIME, WHERE AM I IF I AM EVERYWHERE?[90]

Aitken's recent work seems to occur in such a non-site where time and space must be redefined and our presence becomes, "as random as those phantom particles whose position or speed may perhaps be known, but never both at once."[91] "You can't stop," whispers the girl's voice. This is the end of time. Things disappear into the vortex of experience. Again and again: eternally. It is your experience, and you can't stop.

90 VIRILIO, *POLAR INERTIA* (LONDON: SAGE, 2000), P. 83.

91 IBID.

CHRONOMETERS

The unfortunate Donald Crowhurst was one of nine competitors who entered the Sunday Times Golden Globe Race in 1968 to be the first to circumnavigate solo non-stop around the world, writes Tacita Dean in an essay titled "Once Upon a Different Sort of Time."[92] Dean, who knows quite a bit about *different sorts of time*, has excavated the tragic yet enthralling narrative of this bizarre hero (she refers to him and his voyage in a number of works). The truth was that Crowhurst wasn't much of a sailor. When realizing that he really had no chance to make it around the globe, let alone win a race with genuine sailors, he set about faking his journey. He broke off radio contact so as not to betray himself. Meanwhile, his overly zealous press agent promulgated his fictive journey and systematically exaggerated his progress to the great excitement of the BBC and the British public. The world believed that he was proceeding as planned and that he, in fact, held a good chance to be the champion of the contest. The truth was very different indeed: Crowhurst no longer knew where he was and, worse, he suffered from "time-madness" – a mental condition resulting from obsessive attempts to measure the time on open sea. He was randomly guessing his position and began making peculiar entries into the logbook that concerned not the journey itself but rather his own private speculations on God, relativity, and the nature of the universe. "Once his sense of time became distorted, he had no further reference point in the shifting mass of grey ocean," writes Dean. When finally giving up, he threw himself overboard, taking the faulty chronometer with him into the depth of the ocean.

I chose this faulty chronometer buried in the deepness of the sea as an emblematic theme with which to end this essay. The futility of the device and the disorientation of its owner seem to me to mirror my own condition, and that of many others, when trying to come to grips

92 DEAN, PP. 34–40.

with the temporal complexities of artworks that in various ways test the boundaries of our traditional understanding of presence in time and space. Unlike the waters of Dean's tragic hero, the territories that I've been trying to navigate are mainly of artificial nature, consisting of visual and kinesthetic machineries. Not all of the works discussed employ new technologies, some make use of apparatuses generally considered obsolete. One thing they have in common: they all concern our sense of temporality – our understanding of things occurring in time and of ourselves as temporal beings. They are all articulations of time and space in a world where these concepts, as Virilio is keen to point out, are being rapidly renegotiated. Today a multiplicity of local times seems to supersede the notion of one absolute time, says Virilio, and the "differential order of speed" introduces us to an "order of light" where the meaning of the three tenses – past, present, and future – acquire a new richness and complexity: "In fact, the order of (absolute) speed is an order of light where the three classical 'times' are reinterpreted in a system that is no longer exactly chronological."[93] In a world in which real-time transmission and tele-robotics have become the most normal of phenomena, the *here* and *now* of experience – already challenged by older techniques of mechanical reproduction – seems to vanish into various forms of tele-presence. Where, then, is man's real *presence* in the world located? That question, it seems, was Crowhurst's most acute concern, and to find an answer he developed an obsessive relationship to his chronometer. *Where, when, who am I?* In the end he didn't know the answer to any of these questions and he had, as J.G. Ballard puts it in a brief gloss on Dean, run out of time: "After circling the Atlantic for months, he was psychologically and spiritually exhausted. The time-less void of an ocean death was all that was left to him."[94]

93 VIRILIO, IBID.

94 J.G. BALLARD, "TIME AND TACITA DEAN," IN *TACITA DEAN* (LONDON: TATE BRITAIN, 2001), P. 33.

Could this also be read as an allegory of the disappearance of Man and his sense of time in today's digitized and automated global environment? And once Man has vanished, who (or what) is going to take his place? The artists explored here seem, roughly, to fall into two categories when it comes to these issues: those who mourn the lost chronometer and engage in an endless endgame, and those who try to envision entirely new forms of life emerging through the interaction with technology. Should an artist who experiments with new means of communication conform to the universal convergence of all traditional mediums and indulge in the free manipulation of data representing sound, vision, and kinesthetic sensations broken down to basic signals? Or is the proper reaction rather to insist on devices that appear utterly outmoded in a world of freely circulating information? Buchloh emphasizes the key role of the outmoded in the work of artists such as Huyghe, who, he claims, endeavors to find ways out of today's "intensification of control." Through the deployment of obsolete devices inside the most developed forms of visual and spatial domination, Huyghe "mobilizes an allegorical counterforce," says Buchloh – "a sudden temporal and spatial break from the apparently invincible spell and hermetic closure that the languages of media technology, architecture, and design have established in the service of spectacle and commodity production."[95]

When forms of communication grow old, they become "an index of an understanding of a world lost to us,"[96] says Douglas in response to the question of the role of outdated technologies in his work. So many artists today seem interested in the very notion of the outmoded. No doubt Dean is deeply attracted to various forms of obsolescence and, as she explains, "courts anachronism – things that were once futuristic but are now out of date." Her choice of medium,

95 BENJAMIN BUCHLOH, "CONTROL, BY DESIGN," *ARTFORUM*, SEPTEMBER 2001, P. 163.

96 DOUGLAS IN WATSON, THATER, CLOVER, P. 9.

film rather than video or digital imagery, clearly relates to this interest: "So obsolescence is about time in the way film is about time: historical time; allegorical time; analog time. I cannot be seduced by the seamlessness of digital time; like digital silence, it has a deadness."[97] She opposes this dead time to the time of old mediums. A time that you can hear; a time that is somehow alive: "I like the time you can hear passing: the prickled silence of magnetic tape or the static on the record." The chief theorist of obsolescence, Benjamin, spelled out most of these motifs already in the 1930s. The emergence of a new technology always gives rise to new artistic and political hopes that tend to fade rather quickly. It's not until the moment a technological device is "eclipsed by its obsolescence" that something happens: its "armoring" breaks down and it "releases the memory of its original promise."[98] This *Hoffnung im Vergangenen* (hope in the past) has been analyzed by Peter Szondi as the temporal figure that characterizes Benjamin's thinking on the whole.[99] It is not just a question of ruins and outmoded technologies but, ultimately, of the very structure of history itself: "The past carries with it a temporal index by which it is referred to redemption."[100]

Dean's piece *The Green Ray (2001)*, the most striking articulation of such a promise of the past that I know of, is also an exploration of obsolescence. It's about the rare ray of light that allegedly becomes visible the moment the sun sets into a clear and crisp horizon. Few people are certain to have seen it, and nobody has been able to document it before Dean. Eric Rohmer, for instance, who made the phenomenon legendary, faked his version in postproduction. In

97 TACITA DEAN, *OCTOBER* 100, SPRING 2002, P. 26.

98 KRAUSS, IBID.

99 PETER SZONDI, "HOFFNUNG IM VERGANGENEN. ÜBER WALTER BENJAMIN," IN *SATZ UND GEGENSATZ* (FRANKFURT AM MAIN: INSEL VERLAG, 1964), PP. 79–97.

100 WALTER BENJAMIN, P. 245.

Dean's work, the mystical green light becomes an example of that "weak messianic power" of the past that Benjamin explored so zealously. The green ray is visible only on film, not on digital video. Dean writes, "There, unmistakable, defying solid representation on a single frame of celluloid, but existent in the fleeting movement of film frames, was the green ray, having proved itself too evasive for the pixilation of the digital world."[101] Thus, the material support of an old artistic discipline is bestowed with almost mystical qualities, and the work is no longer only about the numinous cosmic ray, but just as much about vision itself and, according to the artist, about the very fabric, material, and manufacture of film.

The deployment of obsolete devices is one method to dodge the reductive force of the culture industry and, in Rosalind Krauss's view, a way to get a brief glimpse of an outside to the totality of technological space. One can establish this detour via past means of communication in a number of artists' work, and it would be easy to make the list of artists even more extensive. In the end, this seems to me a too markedly nostalgic approach – artistically attractive, even seductive, but ultimately incapable of anything but the reproduction of habitual forms of subjectivation, and, hence, fruitless. Are there any other options?

Quasi una Fantasia: are there alternative approaches that invest in the future rather than in futuristic visions that already belong to the past, i.e., in anticipation rather than in intricate forms of recollection? Let's for a moment try to imagine new forms of affirmation of technological space instead of the well-known yearning to escape into a sphere outside technology via obsolete hopes of a future that never arrived. What forms of subjectivation could develop through an emphasis on futurity and through a search for "weak messianic power" not in forms

101 DEAN, "THE GREEN RAY," IN *RE: THE RAINBOW*, ED. ARIS FIORETOS (LUND: PROPEXUS, 2004), P. 9.

of technology that have lost their function but in those emerging, i.e., instruments still awaiting final interpretation and application? The labyrinths of pastness of Ahtila, the fractured self of Douglas, and the melancholic gaze of Dean are all attractive but ultimately they represent positions that, from a philosophical point of view, are already fully explored. These works refuse to confront the "ever-intensifying incursions of a new technological imaginary," which, in Buchloh's words, "enters and expands into every recess of our conscious and unconscious life."[102] They offer variations of that same analytic of finitude that lets a retreating origin return according to rules that have already been set. Theoretically, this is well-known territory and the works fit perfectly into Benjamin's redemptive figure of thought (Benjamin the melancholic, not the author of "The Work of Art in the Age of Mechanical Reproduction" and "The Author as Producer"), and, hence, promise nothing fundamentally new when it comes to the position of the subject. The possibilities of this game are exhausted, and there is no place for the unforeseen.

"We have to promote new forms of subjectivity," according to Foucault, who spelled out a program of refusal and resistance: "Maybe the target nowadays is not to discover what we are, but to refuse what we are."[103] This is certainly a more risky strategy that demands journeys into uncharted terrain. Are there artists who confront the conditions governing present experience? I actually do think so. The heterogeneous network of flows and pulses, open-ended and unpredictable, that we encounter in Aitken's *electric earth*, offer a glimpse of an unknown and threatening landscape. And Parreno's art of the future at loggerheads with science as well as with fiction seems to me

102 BUCHLOH, "OUR OWN PRIVATE MODERNISM," *ARTFORUM*, FEBRUARY 2000, P. 201.

103 MICHEL FOUCAULT, "THE SUBJECT AND POWER," IN HUBERT L. DREYFUS & PAUL RABINOW, *MICHEL FOUCAULT: BEYOND STRUCTURALISM AND HERMENEUTICS* (CHICAGO: THE UNIVERSITY OF CHICAGO PRESS, 1982), P. 216.

to hint at entirely new forms of experience that, with Lewis Carroll's words, force us out of our old Euclidean skin. *El Sueño de Una Cosa*, Parreno's fantastic "story" of anomalous growth and synthetic vegetation, is a work of anticipation and arrival. Totally incapable of nostalgia, he creates works that require a different grasp of evolution, chronology, and perhaps even of life itself. Here an entirely new dream of a thing emerges, and not one already dreamt by previous generations. Similarly unforeseen, the puzzling setting for Parreno's *The Boy from Mars* – an animal-powered generator and storage system (somehow animal, plant, and machine at once) – emerges as a cipher for life forms yet to come.

We then have to inquire: who comes after Man? "It is a problem where we have to content ourselves with very tentative indications if we are not to descend to the level of cartoons," cautions Deleuze in a prophetic text on the formation of the future. It will be neither Man nor God, he contends, i.e., neither a being defined through constitutive finitude nor one characterized by divine infinity. Rather, what we may expect is an entirely new kind of "fold" – a constellation of forces involving silicon rather than carbon and producing a being that, one must hope, "will not prove worse than its two previous forms." This is Deleuze at his most futuristic: "The forces within man enter into a relation with forces from the outside, those of silicon which supersedes carbon, or genetic components which supersede the organism, or agrammaticalities which supersede the signifier."[104] This new "agrammatical" life form is, according to Arthur Rimbaud's formula, the man who is "in charge of the animals." And that is not enough. Rather, it is man "in charge of the very rocks, or inorganic matter (the domain of silicon)." Aitken's bleak moon over the empty desert, witness to an infinite and circular story about diamonds and sublime machines, is perhaps anticipating the arrival of this new being. We will

104 DELEUZE, *THE FOLD*, PP. 131F.

need new devices and tools for orientation. The old machines carry no hope; they are simply outmoded. No player piano or textile-factory machinery as in Douglas's work, no obsolete chronometer at the bottom of the ocean or prickled silence of magnetic tape as in Dean's cinematic nostalgia. A cycle of death rather than of life, the elaborate automated environment – this luminous "diamond sea"– seems oddly animated yet devoid of life as we know it. Things recur eternally, but there is no one there. Or is someone arriving?

The warmth of a solar ray mysteriously changing color at sunset would be comforting, but is no longer what can be expected. If anything emerges here it's going to be more unsettling, if at all visible to us. A new constellation demanding a radically new *chronology*? Not the finite figure of time affecting itself (thus, producing the temporal interiority known as Man), nor the infinite intelligence of a divine being. Rather, an entirely new fold. A new sense of time, a new chronology. "And is this unlimited finity or superfold not what Nietzsche had already designated with the name of Eternal Return?" inquires Deleuze, unwilling to descend to the level of comics.

Is someone arriving?

Bright lights in the sky, shining stars or luminous ships. Not one, but obviously many … Is someone (or something) arriving?

The Eternal Return, as we saw, is a necessity that must be willed: only he who I am now can will the necessity of my return and all the events that have led to what I am. In short, that same old spider *dragging itself towards the light of the moon and that same moon-light, and you and I whispering at the gateway, whispering of eternal things, haven't we already coincided in the past? And won't we happen again on the long road, on this long tremulous road, won't we recur eternally?*

PHILIPPE PARRENO, *THE BOY FROM MARS*, 2003

35MM FILM, 11 MINUTES, DOLBY SR, PRODUCTION: ANNA SANDERS FILMS, 2003

MUSIC WRITTEN AND INTERPRETED BY DEVANDRA BANHART, COURTESY AIR DE PARIS, PARIS.

A bi-weekly seminar at the Städelschule in Frankfurt about the work of Eija-Liisa Ahtila, Doug Aitken, and Stan Douglas that took place in 2003 was the starting point of this essay, which is basically an edited version of my mazelike seminar notes. In the spring of 2004, I was invited to give the lecture "Zeit Installieren" (Installing Time) at the Hochschule für Gestaltung in Karlsruhe, which gave me the opportunity to present some of the ideas to a philosophically advanced audience. Many of the theoretical ideas and some analyses of single artworks have appeared in different (sometimes hardly recognizable) form in articles published in magazines (mainly *Artforum* and *frieze*), books and catalogs such as my *The Hospitality of Presence: Problems of Otherness in Husserl's Phenomenology* (Stockholm: Almqvist & Wiksell, 1998), *Eija-Liisa Ahtila* (Kassel: Fridericianum, 1998), *Doug Aitken* (London: Phaidon, 2001), and *Here Comes the Sun* (Stockholm: Magasin 3, 2005).

I want to thank April Lamm, Spencer Finch, and Sven-Olov Wallenstein for their constructive criticism of the manuscript.